CANTERBURY PUBS

JOHNNY HOMER

AMBERLEY

This book is dedicated to the beautiful Harriet and Lydia, who have both put up with the anti-social hours, not to mention mounds of paperwork that have accompanied the writing of Canterbury Pubs.

First published 2015

Amberley Publishing
The Hill, Stroud
Gloucestershire, GL5 4EP

www.amberley-books.com

Copyright © Johnny Homer, 2015
Maps contain Ornance Survey data.
Crown Copyright and database right, 2015

The right of Johnny Homer to be identified as
the Author of this work has been asserted in
accordance with the Copyrights, Designs and
Patents Act 1988.

ISBN 978 1 4456 5093 7 (print)
ISBN 978 1 4456 5094 4 (ebook)

British Library Cataloguing in Publication Data.
A catalogue record for this book is available from
the British Library.

Typesetting by Amberley Publishing.
Printed in the UK.

Contents

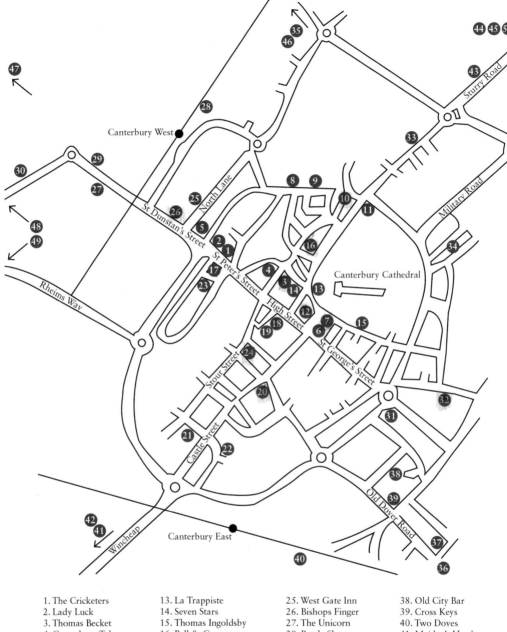

1. The Cricketers	13. La Trappiste	25. West Gate Inn	38. Old City Bar
2. Lady Luck	14. Seven Stars	26. Bishops Finger	39. Cross Keys
3. Thomas Becket	15. Thomas Ingoldsby	27. The Unicorn	40. Two Doves
4. Canterbury Tales	16. Bell & Crown	28. Bottle Shop	41. Maiden's Head
5. The Pound	17. Black Griffin	29. Monument	42. King's Head
6. The Shakespeare	18. Cherry Tree	30. Eight Bells	43. Run of the Mill
7. City Arms Inn	19. The Foundry	31. Flying Horse	44. Fordwich Arms
8. Miller's Arms	20. Three Tuns	32. Two Sawyers	45. George & Dragon
9. The Dolphin	21. Limes	33. Penny Theatre	46. Tyler's Kiln
10. The Parrot	22. White Hart	34. New Inn	47. Royal Oak
11. Jolly Sailor	23. Carpenter's Arms	35. Ye Olde Beverlie	48. Old Coach & Horse
12. Old Buttermarket	24. Old Brewery Tavern	36. Bat & Ball	49. Gentil Knyght
		37. Phoenix	50. Ye Olde Yew Tree

Introduction

On 8 September 1299, Edward I married Margaret, the sister of King Philip IV of France, at Canterbury Cathedral. The wedding was a grand event that attracted royalty and nobility from across Europe. As a result accommodation within the city walls was at a premium.

Among those lucky enough to wangle an invite, and to secure a precious billet in the heart of the city, was the ambassador to the emperor of Germany. He was obviously pleased with his lodgings and was inspired to write: 'The inns in England are the best in Europe, those of Canterbury are the best in England, and the Fountain the best in Canterbury.'

Alas The Fountain, which pre-Chaucer was probably the most famous inn anywhere in the land, is no longer with us, a victim of German bombs in 1942. But Canterbury remains a city, colourful and cosmopolitan and bustling, renowned for its hospitality, and nowhere is this better illustrated than in the city's many and diverse drinking venues, from old hostelries and battered backstreet boozers through to cutting-edge brewpubs and craft-beer bars.

People have been enjoying the hospitality offered by Canterbury's many watering holes since before the city was immortalised by Chaucer back in the fourteenth century. Today, a teeming mix of locals, students, tourists and modern-day pilgrims are just as spoilt for choice

Ale, Hops and a City of Brewers

If you like pubs then Canterbury will not disappoint, and it has always been the way. It was around fifty years after the murder of Thomas Becket in 1170 that a shrine was created in his honour, and Canterbury has been a place of pilgrimage ever since. To cater for these thousands of visitors, immortalised most memorably by Chaucer, a number of alehouses and inns soon sprung up and Canterbury became famous for its welcome.

In time the city also became famous for the quality of its ale and, once hops had become established in this country, for its excellent beer. Given its location, close to some of the earliest hop gardens to be cultivated in this country and also to plentiful supplies of top-quality barley, brewing was one of the city's biggest industries.

Hops are still harvested just a few miles from Canterbury.

In 1724 Daniel Defoe, writing in his *A Tour Thro' the Whole Island of Great Britain*, recorded that hops were being grown within a mile of Canterbury Cathedral and dried within the city walls.

There were still as many as a dozen brewers operating in Canterbury in the last days of the nineteenth century, but a combination of takeover and consolidation steadily reduced that number and by the 1960s Canterbury had no brewing industry to speak of.

In recent years, I am happy to report, brewing has returned to the cathedral city and the Foundry brewpub in White Horse Lane is now producing some wonderful cask ales and craft beers. Slightly further afield, Canterbury Ales near Chartham and Wantsum in Hersden also continue to flourish.

The number of pubs in Canterbury, in line with the national trend, continues to decline. There were in the region of 160 in the late 1890s, but by the time of Edward Wilmot's comprehensive pub survey of 1965 that figure had drastically reduced, and it has been a downward curve ever since. But sometimes it is quality not quantity that counts and modern-day Canterbury has some wonderful pubs.

I have divided this book into four distinct parts. The majority of pubs featured here are in Canterbury's city centre, roughly within the confines of the old city wall. I have divided these into two parts, those roughly north of St Peter's Street and its continuation as the High Street, and those roughly south.

The third chapter deals with those pubs either just outside, or within a short walk of, the city walls.

The final section is devoted to those pubs slightly further afield, hostelries that you might have to use a bit more boot leather to reach. For some of them you might even have to drive. However, a good walk never did anyone any harm and is an excellent way to work up a thirst.

Johnny Homer, June 2015

Within the City Walls – North

THE CRICKETERS, ST PETER'S STREET

While Canterbury as a city has historically struggled to support a senior football club, as the continued struggles of the current incarnation of Canterbury City FC all too sadly testify, cricket has long thrived in the area and Kent County Cricket Club are based at the Spitfire Ground, formerly known as the St Lawrence Ground, a mile or so outside the city walls on the Old Dover Road.

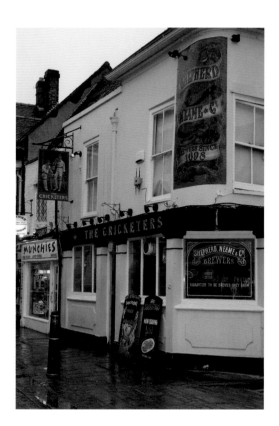

The Cricketers in St Peter's Street
(Shepherd Neame).

The Cricketers, conveniently positioned on the corner of bustling St Peter's Street and the more sedate St Peter's Lane, is one of three pubs in the area with especially strong links to the sport.

Originally called the Cherry Tree, there are records dating from 1692 of a tavern on this site. By 1838 the pub was calling itself the Kentish Cricketers, a change of name probably reflecting the fact that the previous year Kent was unofficially declared England's 'champion' cricket county. It is worth noting that although Kent CCC were not founded until 1842, a side representing Kent had been involved in inter-county matches as early as 1709, when they faced a team representing Surrey. Much of the early evolution of cricket as we know it today took place in this neck of the woods.

Canterbury Scene

For many years the pub was owned by the famed Fremlins brewery of Maidstone, who later became Whitbread Fremlins after being consumed by the giant London-based company. Faversham's Shepherd Neame, Britain's oldest surviving brewer, acquired the pub in 1972 and in 1997, around the time they started brewing Dutch pilsner Orangeboom under licence, changed its name to Oranges. Fortunately heritage and history eventually prevailed and for many years now the pub has been known simply as The Cricketers.

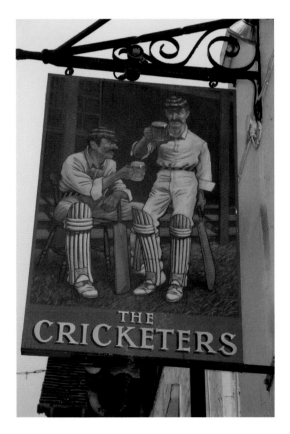

The Cricketers boasts one of Canterbury's finest pub signs (Shepherd Neame).

In April 2008 Richard Coughlan, drummer with legendary Canterbury-scene band Caravan, took over as landlord of the pub alongside his wife Sue. The Coughlans had previously transformed the Sun Inn in Faversham into an award winning pub-hotel and this winning touch soon turned the Cricketers into a welcoming city-centre hostelry, popular with both students and tourists, which it remains today.

Taking pride of place on the wall of the front bar was a framed gold disc for Caravan's 1971 album *In The Land of Grey and Pink*, which remains a seminal, if somewhat whimsical, piece of English psychedelia. Sadly Richard Coughlan passed away in December 2013, aged just sixty-six.

LADY LUCK BAR, ST PETER'S STREET

As mentioned elsewhere in this book, these are difficult times for the Great British public house and hundreds are closing all across the country every year. To survive some are adapting, thinking outside the box to use modern parlance. That's certainly the case with The Lady Luck bar, a central-city venue that has been successfully reinvented.

The pub started life as the Carpenter's Arms, probably in the late seventeenth century, but by 1760 was definitely going by the name of the Three Compasses, which it was known as until 2001. Three compasses feature on the coat of arms of the Carpenter's Company, one of the City of London's historic livery companies, so this wasn't perhaps such a drastic change of name as one imagines.

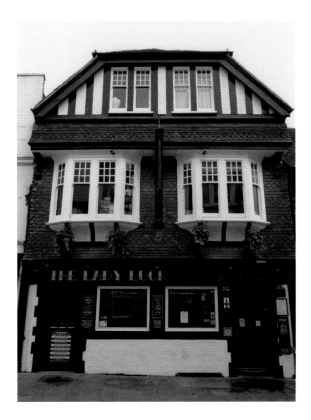

The Lady Luck in St Peter's Street.

Something of an identity crisis seems to have struck at that point in the pub's long history. Until 2007 it traded as the Westbar, and briefly from 2007 it became City One. Both incarnations featured rather garish pub fronts, quite a contrast to the building's unspoilt upper floors.

Rebirth and Regeneration

In the summer of 2009 Lady Luck opened its doors for the first time, and it has been a popular drinking and music destination ever since with rock and roll, in all its many and varied guises, at the heart of the pub.

A busy venue that seems to be buzzing at every hour of the day, it hosts live music performances, DJ sets and a number of one-off themed party nights. These attract a colourful and mildly alternative clientele, as the gallery section of the pub's website illustrates. You don't have to have a tattoo to party at the Lady Luck, but an awful lot of the customers do.

The pub is also rightly proud of its jukebox, which covers many musical bases from 50s rock-and-roll right through to goth and heavy metal. Chris de Burgh fans should perhaps give the place a miss.

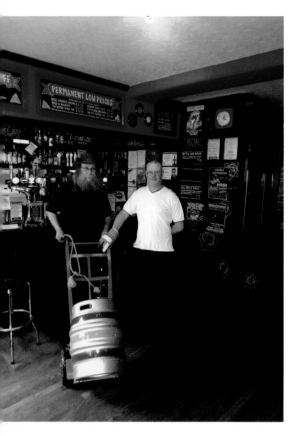 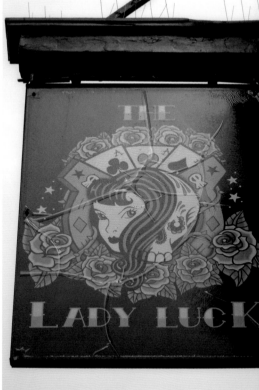

A Rockin' Robin Brewery delivery arrives at the Lady Luck.

The Lady Luck is clearly not everyone's pint of snakebite then, although it attracts a more varied clientele than you might at first assume, especially during the afternoon and early evening when St Peter's Street becomes awash with a human sea of pedestrians. Also, refreshingly for a pub that attracts a predominantly younger customer base, they keep a selection of cask ales that have earned them Cask Marque accreditation.

THOMAS BECKET, BEST LANE

What, I wonder, would Canterbury be like today if Thomas Becket had not been slain back in 1170? There would have been no shrine for a start, and, without its shrine to Becket, Canterbury Cathedral would probably never have become the place of pilgrimage that over hundreds of years it has. And without the thousands of pilgrims who flocked to the city, and indeed continue to flock, we would have a lot fewer inns and taverns. It really doesn't bear thinking about.

The Thomas Becket pub in Best Lane, named in the great man's memory, is a handsome old hostelry adorned with one of the most striking and beautiful pub signs you're likely to come across. One that appears almost luminous when seen in the right light.

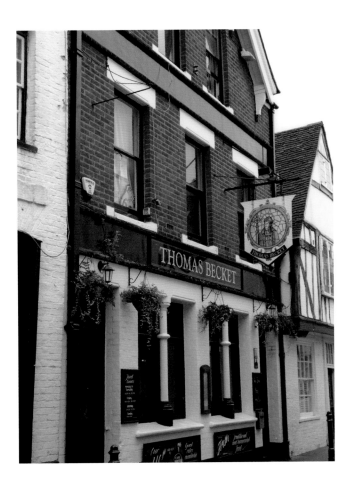

The Thomas Becket in Best Lane.

For most of its history, however, this pub was known as the Bricklayer's Arms. It seems that many working in the building trade would congregate in Best Lane, formerly a busy thoroughfare where industries as diverse as stained glass and carriage making were based. When a tavern was first licensed here in the 1770s it housed a trade association for bricklayers, so the pub's adopted name was an obvious one.

Anniversary Marked by Change of Name

In 1970, to mark the 800th anniversary of Becket's murder, the Bricklayer's Arms became the Thomas Becket. People tend to get quite irate sometimes when pubs change their name, but no one seems to have minded too much in this instance. The brickies, it seems, had all moved on.

Back in 1840 the pub was acquired by Faversham brewer Rigdens, and some lovely etched windows have survived from that period. They made things to last back then.

In 1949 Rigdens, then trading as George Beer and Rigden, were consumed by Maidstone's Fremlins and the pub passed into their hands. In the dog-eat-dog world that was the post-war English brewing industry Fremlins itself was eventually gobbled up by London company Whitbread.

Today the Thomas Becket is a freehouse and it takes its beer seriously.

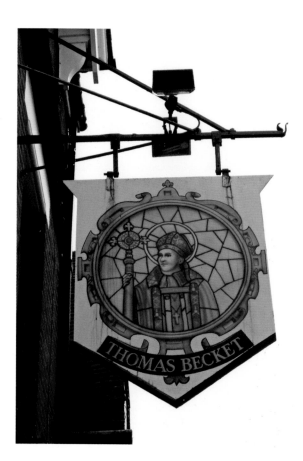

The Thomas Becket's pub sign can seem luminous at times.

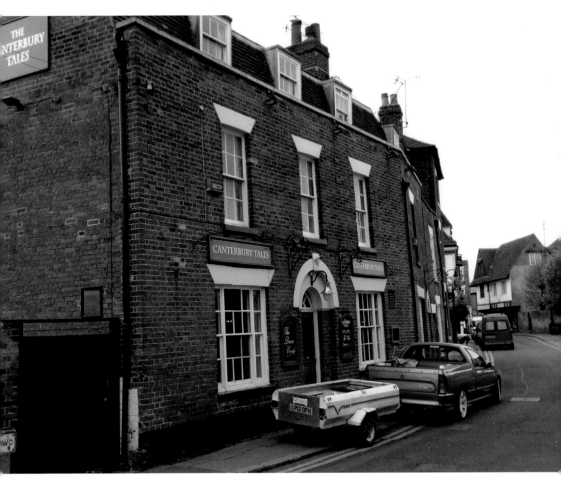

The Canterbury Tales, opposite the Marlowe Theatre. Greasepaint optional.

THE CANTERBURY TALES, THE FRIARS

Canterbury once boasted several theatres offering a variety of entertainment, from music hall at the Alexandra in Northgate to more formal gatherings at the Theatre Royal, Guildhall Street, where Charles Dickens famously gave a reading from *David Copperfield*. These days the Marlowe, situated just off St Peter's Street in the Friars, is the city's main venue.

Formerly a cinema – for many years it was the Odeon – it was converted into a theatre in 1984 by Canterbury City Council and between 2009 and 2011 was demolished and almost completely rebuilt; it was replaced with a state of the art modern auditorium. The main hall has a capacity of 1,200.

Of course thespians and theatregoers are a notoriously thirsty bunch, and in this case are well served by the Canterbury Tales, a solid-looking old pub which stands directly opposite today's Marlowe Theatre. It caters both to those with a penchant for greasepaint and also the city's large and energetic student population.

Mitre Inn

Until 1981, when it changed its name to the present Canterbury Tales, the pub was known as the Mitre Inn and as such was in business from 1845. The current building is Grade II listed and for many years was under the control of Whitbread.

In contrast to some pubs in Canterbury that have changed their name in recent years to emphasise the connection with the cathedral – the Thomas Becket in Best Lane, for instance – the people in charge at No. 12, The Friars, have opted for a different tact. Is Chaucer really a bigger draw these days than the Cathedral and Metropolitical church of Christ at Canterbury? A topic to discuss over a pint or two perhaps, but not too heatedly.

The Canterbury Tales lives two lives. From early evening its ground floor bar caters primarily to theatregoers, who can even order their interval drinks in advance. However, the pub also enjoys a late licence from Monday through till Saturday, when last orders are called at 1.00 a.m., and this has made it a popular venue with students eager to lessen the stresses and strains of intensive study.

From Thursday through to Saturday, from 10.00 p.m. until closing time, the first-floor private function room opens as the Dress Circle, promising cocktails and even karaoke when the wind is blowing in the right direction. Greasepaint is optional.

THE POUND, POUND LANE

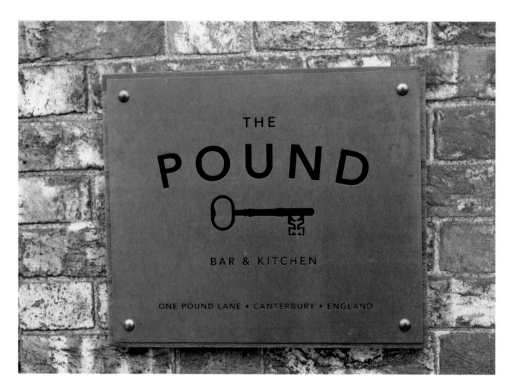

The sign of the Pound, located in a former police station.

Without doubt the most unusual drinking venue in Canterbury is The Pound, a former police station that has been converted into a rather striking bar and restaurant space. Located at the St Dunstan's end of Pound Lane in the shadow of the Westgate Towers, the bar's terrace area looks out over the River Stour and at the Whetherspoons-owned West Gate Inn on the other side of North Lane. The two venues couldn't be more different.

A police station opened here in 1829 and the boys in blue remained until the early 1960s when the station was relocated to a site near the Riding Gate roundabout. The Pound Lane building was then converted into a music school and many a weary shopper surely had their load lightened a little by the strains of Mendelssohn and Mozart that could be heard floating out through open windows on hot summer days.

In 2014 business partners Stephen Allen and James Caldon were awarded a lease for No. 1 Pound Lane and in December the same year, after a costly conversion, the venue opened as a bar and restaurant.

A Drink in the Clink

The interior of The Pound is certainly striking. Many of the walls have been stripped back to their bare brick while seemingly no expense has been spared on fixtures and

Inside The Shakespeare, Butchery Lane (Shepherd Neame).

fittings.

Perhaps the most arresting part of the project, however, is the transformation of the former prison cells into private dining and drinking rooms, complete with surviving cell doors, iron grilles, vaulted ceilings and original Victorian tiling.

Much of the emphasis here is on cocktails, but also available are a number of craft beers. Both suggest a younger clientele are the target customer.

But if you do visit the Pound, and happen to find yourself sitting in one of the former prison cells, please raise a glass to the countless poor unfortunates who have been there before you.

THE SHAKESPEARE, BUTCHERY LANE

There is an awful lot we don't know about Shakespeare, but one thing we can be sure of is that the Bard liked his ale. *In The Winter's Tale* Autolycus, described in the play's *dramatis personae* as a 'rogue', declares: 'For a quart of ale is a dish for a king.'

It is, then, no wonder that so many public houses are named after dear old Will, and he would certainly have been at home in Butchery Lane, a narrow thoroughfare with a distinctly medieval feel about it that connects the bustle of Canterbury's High Street with the more sedate Burgate; and be in no doubt that he would have made a point of popping into the pub at No. 5 that is named in his honour.

There were once three taverns in Butchery Lane, named so because it was for many years the centre of the city's meat trade, but now there are just two, the Shakespeare and the City Arms, which stands just yards away. During the Luftwaffe raids of the Second World War several high explosives were detonated here and almost the entire row of buildings that once stood opposite were lost. They included another pub, the aptly named Butcher's Arms.

Renovation and Rebirth

A pub is listed at this address in the late eighteenth century, although the building is probably early sixteenth century in origin. Despite its narrow and rather deceptive frontage, suggesting a small interior, it offered hotel accommodation well into the 1960s when it was known as the Shakespeare Inn.

Long operating under the auspices of Shepherd Neame, one of the Faversham brewer's earliest forays into Canterbury, it was renamed Casey's in 1995, during which time it was a popular student haunt.

In late 2013, however, the pub reverted to its old name following a major renovation and relaunch under the stewardship of Gareth Finney and Dan Sidders, also licensees at The Parrot and Ye Olde Beverlie, another brace of very old Canterbury pubs.

More emphasis is now on food at their Butchery Lane outpost, although it is still ostensibly a pub. It also stretches some way back from its frontage and now extends to a former gift shop at the rear on Burgate, which has been named Wine at the Shakespeare. This looks out onto Canterbury Cathedral's Christ Church gate entrance and is all very picturesque.

Opposite: The Shakespeare, *c.* 1890, and now (Shepherd Neame).

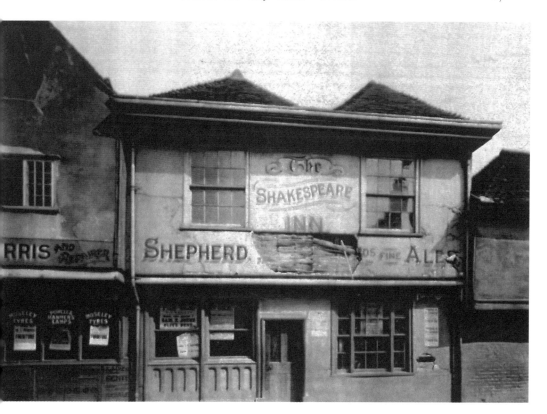

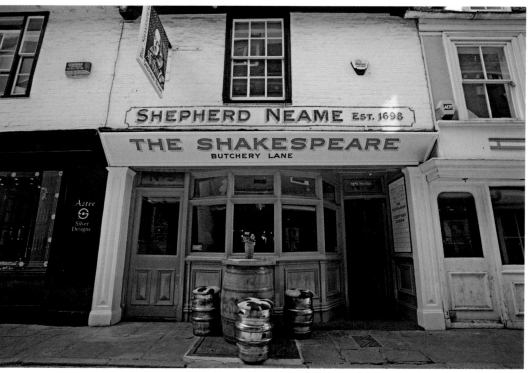

THE CITY ARMS INN, BUTCHERY LANE

To walk Butchery Lane's short length is to almost step back in time, for despite the modern street furniture and shop fronts it has a distinctly medieval feel. Many years back it was called Angel Lane, though, as its current name suggests, this was once where the city's butchers lived and worked. It comes as no surprise then that the City Arms Inn at No. 7, one of two pubs in the lane, is one of Canterbury's oldest.

The building, tall and narrow, dates from the fifteenth century. In the city licensing list of 1692 it is called the Morocco and throughout the eighteenth and nineteenth centuries seems to have changed its name on several occasions, albeit only slightly. For a time it was known as the Angelo Castle, also at times the Angel's Castle and the Angel and Castle.

It was first registered as the City Arms in 1892 and the pub sign has always adopted the city of Canterbury's coat of arms, featuring an heraldic leopard and three black choughs. The inscription reads *Ave Mater Angliae*, which translates as look and learn.

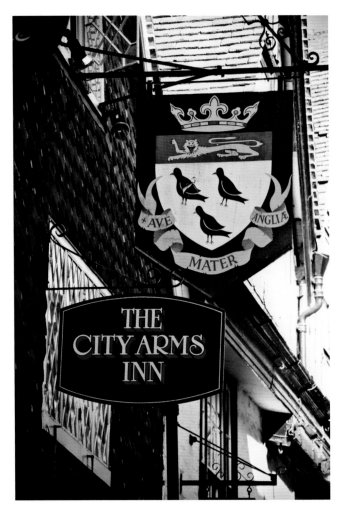

The City Arms Inn,
Butchery Lane.

Bomb Damage

During the German air raids of the Second World War the west side of Butchery Lane took a direct hit and the row of buildings were almost entirely lost. One positive to come from the bombing was the discovery of the ruins of a Roman townhouse and a very rare mosaic pavement. Over 1945 and 1946 these were painstakingly excavated and are now the main feature of the Canterbury Roman Museum, which stands almost opposite the City Arms.

The pub, a former Fremlins house and subsequently a Whitbread Fremlins hostelry, suffered only slight damage from the Luftwaffe bomb blast but wasn't so fortunate in 2001 when it was badly damaged in a fire. It took three years to complete the building's refurbishment and renovation and it eventually reopened in August 2004, thankfully with most of its original character and charm intact. This rise from the flames is well documented in pictures and words in the small back bar.

Today it is operated by Stoneset Inns, the same company who operate the nearby Foundry brewpub, home of the innovative Canterbury Brewers. As a result the City Arms Inn carries a very impressive range of both cask and craft beers.

Inside the City Arms Inn.

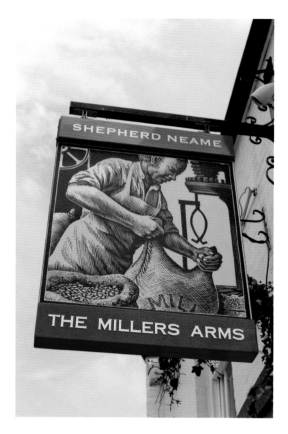

The Miller's Arms, St Radigund's Street (Shepherd Neame).

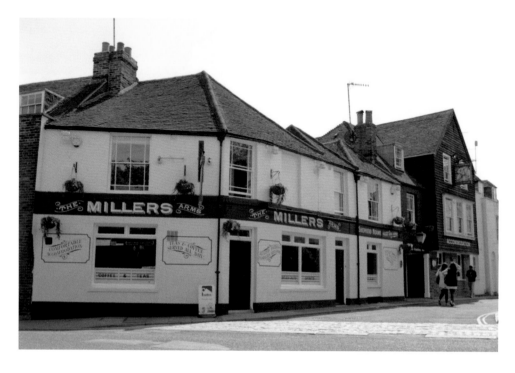

THE MILLER'S ARMS, ST RADIGUND'S STREET

There are many who labour under the misconception that The Miller's Arms pub takes its name from Chaucer's *The Miller's Tale*. The truth, however, is more prosaic, although to my mind no less endearing.

Given that the Great Stour flows in this neck of the woods it comes as no surprise that a mill, called Abbot's Mill originally, stood in the area as early as the twelfth century to harness the power of the often fast flowing river. A huge six-storey replacement was constructed in the late eighteenth century, overseen by John Smeaton of Eddystone lighthouse fame no less and reckoned to be the second biggest building in Canterbury after the Cathedral. It became known as Denne's Mill in the 1890s after being bought by local businessman Thomas Denne.

In 1826 The Miller's Arms pub opened directly opposite the mill to cater for local workers, of which there were once many. Milling, after all, is thirsty work. It was built on reclaimed marshland. However, going back to Chaucer, this historical fact hasn't prevented some artistic licence over the years when it has come to the pub's sign, and on several occasions during its long history an image of Chaucer's miller – 'a stout and evil churl, fond of wrestling' – has featured.

Mill Destroyed by Fire

On the morning of 17 October 1933 a fire broke out in the mill's hayloft and was soon burning out of control. It turned into one of the most spectacular conflagrations to grip Canterbury in many years and took fire engines from as far afield as Herne Bay to help extinguish it. During the fire The Miller's Arms suffered some limited damage. Thankfully it survived relatively intact and today enjoys Grade II listing.

Over the years the pub has been extended along Mill Lane and was a freehouse for some time. Today The Miller's Arms is a swish and recently updated Shepherd Neame hostelry offering accommodation and a good variety of food and drink. On quiet summer evenings you can sometimes hear the Great Stour flow gently.

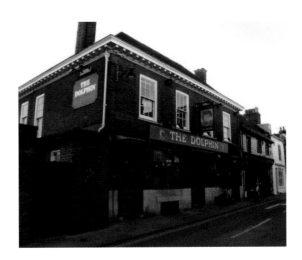

The Dolphin, St Radigund's Street
(Paul Skelton).

THE DOLPHIN, ST RADIGUND'S STREET

On the wall of the building next door to the Dolphin is a plaque commemorating Count Louis Zborowski. As a teenager in 1911 Zborowski inherited a fortune (£10 million in cash plus a vast property portfolio, much of it in New York) and this allowed the then sixteen-year-old to devote his time and energy to the main passion in his life, motor cars. Here, in sleepy Canterbury, was his workshop.

It is not on record whether he ever nipped into The Dolphin for a bag of pork scratchings and a pint of mild, but this venerable old city pub has been putting a tiger in people's tanks for more than 180 years. It remains one of Canterbury's most lauded pubs, for the quality of both its ale and food. It is one of six central Canterbury venues featured in the 2015 edition of CAMRA's *Good Beer Guide*.

There are records of a pub on this site in the 1820s and from the 1830s trading as The New Dolphin. There was already an established pub called The Dolphin in Canterbury, a much older inn dating from the late seventeenth century and located in Burgate, but that disappeared sometime in the mid-nineteenth century.

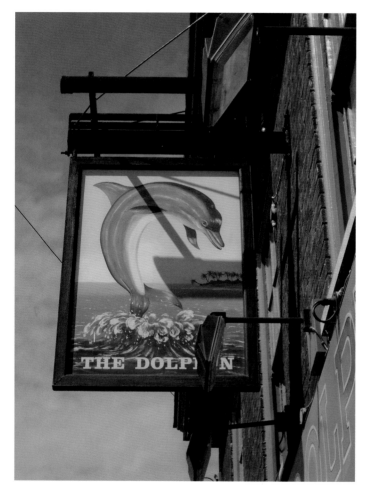

Many pubs go under the name of The Dolphin.

The Sign of the Dolphin

Dolphins feature in many British pub names for a number of reasons. Firstly, they were regarded by seafarers as friendly creatures who brought good luck with them. Secondly, they adorn many a coat of arms, including those of the Company of Watermen and Lightermen. In the case of this particular pub its name might have something to do with St Radigund's baths, which once occupied a site directly behind where today's Dolphin stands. Many a swimming club have adopted the Dolphin as their emblem.

George Beer, whose Star Brewery stood at the corner of Burgate and Broad Street until demolition just before the Second World War, acquired The Dolphin in 1865 and, following a merger with Rigdens of Faversham in the 1920s, the pub was rebuilt. The current building dates from 1927 and is both elegant and understated.

Returning briefly to Zborowski, he would die aged just twenty-nine racing for the Mercedes team in the 1924 Italian Grand Prix at Monza, but not before designing a state-of-the-art racing engine that he called Chitty Chitty Bang Bang. The young Ian Fleming once saw the dashing Zborowski race, an event that many years later would inspire a bestselling children's novel and subsequent family film. The rest, as they say, is history.

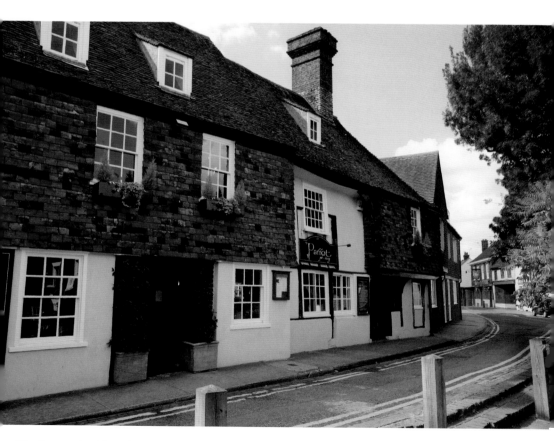

The Parrot in Church Lane (Shepherd Neame).

THE PARROT, CHURCH LANE

There are old pubs in Canterbury and then there are old pubs, and then there is The Parrot in picturesque Church Lane, which declares itself the oldest of them all.

There is some evidence that ale has been sold from this location for at least 600 years and parts of the Grade II -isted building that house the pub today claim an origination of 1370, most likely built on top of surviving Roman foundations. It was formerly known as St Radigund's Hall – St Radigund's Street is just yards away – and some records suggest that during the 1700s it was operating as two separate drinking houses.

The building, by this time divided into several dwellings, was in line for demolition in the late 1930s, but once workmen set about knocking the old place down a number of rare architectural features were discovered to reveal the real age of Nos 3–9 Church Lane. Instead of pulling it down a major restoration programme took place instead.

Simple Simon's

The building was used for a variety of purposes before, in 1987, it opened once again as a pub, named Simple Simon's.

Under the guidance of Michael Patten, Simple Simon's became something of a Canterbury institution, down at heel and scruffy but an essential part of city life for both students 'in digs' and young locals alike. The pub was known for serving

The pretty back garden of the Parrot (Shepherd Neame).

good cask ale when good cask ale was the exception rather than the norm, and would regularly carry up to six different guest beers. For a brief period they even brewed their own, reviving a medieval tradition that the Foundry pub continues today.

The pub also had a reputation for stocking real cider of the 8 and 9 per cent variety, the genuine cloudy stuff a million miles removed from the vapid, chemical mainstream cider of today. Many a weekend hangover was born at Simple Simon's on a Friday night.

The pub was acquired by Young's, formerly of Wandsworth, in 2008 and they renamed it The Parrot, to the dismay of some locals. It is now in the hands of Shepherd Neame who have done a fabulous job of restoration and renovation to make it a truly remarkable place to eat and drink.

Beguiled by The Parrot's antiquity, the fancy sometimes takes me to visit the delightful rear garden and, armed with a pint naturally, admire this lovely old building from the rear as the sun sets on another day. It is possibly as close and you'll come in modern day Canterbury to time travel.

THE JOLLY SAILOR, NORTHGATE

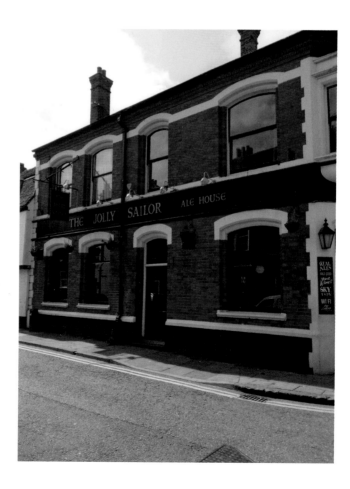

The Jolly Sailor, Northgate.

A good pub should be much more than simply a place to drink, be merry and let your hair down, it should also ideally both reflect and be part of the community around it. That's certainly the case with The Jolly Sailor, a stout old salty seadog of a pub on the corner of the Borough and Broad Street, although it actually boasts the address No. 75, Northgate.

When Ian Blackmore bought the pub back in 2009 he was determined to forge strong links locally. Blackmore knew the pub well from his days at the University of Kent and in 2013 he told local newspaper the *Canterbury Times* that 'from the outset we wanted to re-engage with students and local sports clubs, art groups and societies and to provide a home for their members'.

The pub now offers a base for more than twenty different sports clubs and community and arts groups. With its huge student population, recently estimated at an astounding 31,000, Canterbury is one of Kent's most cosmopolitan urban centres and the Jolly Sailor also provides a gathering place for, in particular, many of the city's American, Irish and South African communities.

Community Hero Award

Blackmore's work in the community was recognised in 2014 when he was shortlisted in the Enterprise Community Heroes Awards. For making the final 18 of this nationwide competition his pub received £5,000, which was ploughed back into improving community facilities at The Jolly Sailor, including the conversion of an upstairs room into a meeting space for the many clubs and societies that congregate here.

But it's not just inside the pub where Blackmore directs his efforts. The landlord was one of the leading lights in a campaign that successfully secured £200,000 of council funds to improve the King's Mile, the name given to a collection of streets close to Canterbury Cathedral, including both the Borough and Northgate.

The Jolly Sailor is also one of several live venues used in the annual City Sound Project music festival, hosting the acoustic stage.

There has been an inn on this site since the late seventeenth century, originally known as the Black Swan. By 1830, after being bought by Rigdens of Faversham, it changed its name to The Jolly Sailor. It was later a Fremlins house. Today's pub is a lively and vibrant meeting place that attracts a mixed bunch of customers, just the way Ian Blackmore and his team like it.

THE OLD BUTTERMARKET, BURGATE

For many who grew up in and around Canterbury, The Old Buttermarket will always be known as the Olive Branch. As such it was a traditional pub with upmarket pretensions, perhaps because of its close proximity to Canterbury Cathedral and its sixteenth-century Christ Church gate which is almost directly opposite.

In late 1997, however, the Olive Branch was acquired by food and drink giant Allied Domecq who, in their wisdom, transformed it into one of their Firkin chain of pubs, renaming it the Franklin and Firkin after 'The Franklin's Tale' from Chaucer's *Canterbury Tales*.

The Firkin chain was the brainwave of David Bruce and launched as a small selection of London brewpubs back in 1979, particularly famed for their potent Dogbolter dark ale.

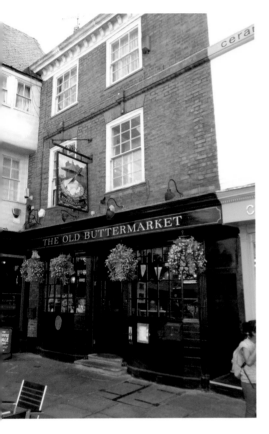

The Old Buttermarket in Burgate.

Allied bought the company in 1991 and in their hands the brand was rolled out across the country – indeed across the globe – although the original brewpub and cask ale ethos was somewhat lost in the process.

This pub has been known as The Old Buttermarket since 2001 and as such is the sole Kent outpost of London pub chain Nicholson's, a wing of the giant public limited company Mitchell and Butler. The pub's interior extends some way back from the street and, not surprisingly given its location, is popular with tourists.

Cathedral Tunnels

There has been a hostelry of one sort or another on this site for more than 500 years and until 1908 it was known as the Black Boy, a former coaching inn.

In the pub's cellar traces of original Roman flint have been unearthed, and the tavern was once connected to Canterbury Cathedral by a series of tunnels, very convenient for members of the clergy seeking to quench their thirst while retaining a modicum of respectability.

Originally known as Bull Stake, where bulls were baited overnight prior to slaughter, in the sixteenth century the Buttermarket housed a covered market building. The

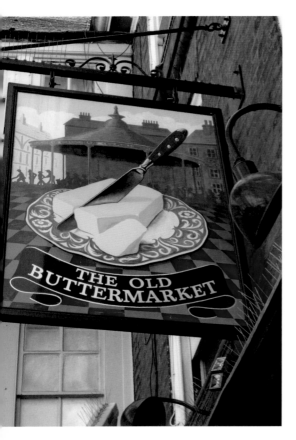
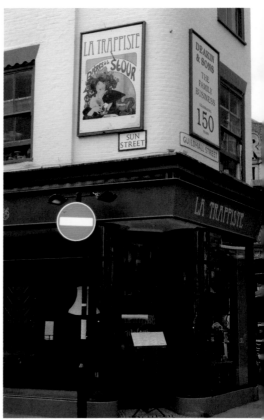

Left: In the background of the signis the old Buttermarket building.

Right: La Trappiste on the corner of Sun Street and Guildford Street.

original structure was replaced in the late eighteenth century by an oval construct supported by sixteen columns, which can be seen in the background of today's pub sign.

The market was demolished in 1888, its site taken by a memorial to Christopher Marlowe, dramatist, poet, alleged spy and son of Canterbury. This, however, was deemed too risqué to stand so close to the Cathedral and was replaced in 1921 by an imposing memorial to the First World War. Marlowe's memorial today stands near the Marlowe Theatre in the Friars.

LA TRAPPISTE, SUN STREET
For generations born and bred in Canterbury, Deakin and Son Gentleman's Outfitters on the corner of Sun Street and Guildford Street was a city institution. It was where men went to buy their casual wear and their formal wear, to pick up sensible tweed and corduroy. Denim? I doubt very much that Deakin and Son ever so much as entertained the idea of denim.

When Deakin and Son called it a day in 2010 the premises were taken over by La Trappiste, itself a father and son affair with Andy and Simon Barrett at the helm. They transformed the premises into a restaurant, coffee shop and bar. Some people bang on about the introduction of café culture into this country, as if putting a table and chairs outside your premises suddenly transforms an English street into a Parisian boulevard, but for the real thing La Trappiste is where you should head.

You can take breakfast here, or just coffee at any hour of the day. You can lunch here and you can dine in the evening here. Or, and this is one of the reasons I include it here, you can just pop in for a drink, pretty much anytime the place is open. Now, that's what I call café culture.

Belgian Beer

And what drink there is here! Most of it from Belgium and most of it wreathed in mystery for many Brits who seem happy to settle for a pint of bland, mass-produced lager.

Belgian beer comes in many styles, much of it unique to a country that is rather unfairly the cause of much mirth to some UK residents.

From Trappist beers through to white beers and fruit beers, and from Abbey beers through to the strange and wonderful Lambic beers – the latter fermented with wild yeast – there is something to suit most tastes. Most of these beers are strong. Some of them are very strong.

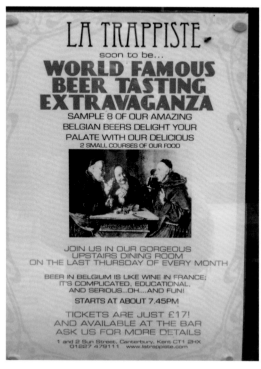

La Trappiste is the place to go for Belgian beer.

To my mind there are two ways to learn about the wonders and splendour of Belgian beer. One is to search out a copy of *Great Beers of Belgium*, a seminal tome by the late, great beer writer Michael Jackson. The second is to visit one of La Trappiste's tasting evenings in which you can try eight different Belgian beers, with food. They take place on the last Thursday evening of every month. Best not to ask for a pint of Foster's.

THE SEVEN STARS, ORANGE STREET

Some pubs make quite a lot of their age and antiquity, but others choose instead to just get on with the day to day business of, well, being a pub, preferring not to hang their trilby on the hat peg called history. Such a pub is the Seven Stars in Orange Street.

The pub has been here for many years, certainly as early as the 1660s when it was one of just a handful of hostelries in Canterbury allowed to sell wine under a law introduced during the reign of Edward IV some years before.

The inn traded as the Fox and Seven Stars for many years but from the late 1760s dropped the Fox.

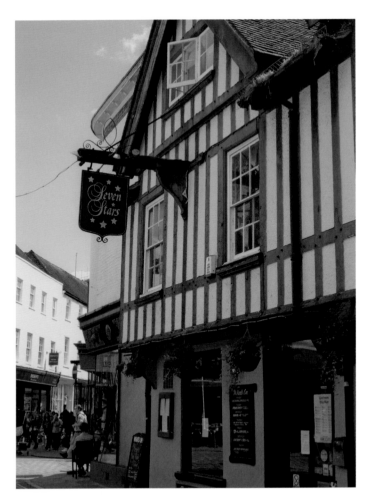

The Seven Stars in Orange Street.

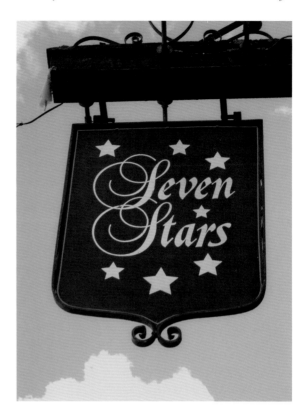

The sign of the Seven Stars.

Orange Street – once called Prince of Orange Street in honour of William III, formerly William of Orange – was once home to Canterbury's original Theatre Royal, which had its main entrance in what is now a City Council car park. The rather grand palace of entertainment backed onto Orange Street and no doubt many a thirsty audience member exited here, perhaps before the final curtain, and made straight for the Seven Stars for a nightcap before the journey home. The theatre facade, or at least some of it, can still be seen to this day just a few yards along from the pub.

Today the Seven Stars seems to lead something of a double life. By day, given its proximity to Canterbury Cathedral, it is busy with visitors and tourists seeking some kind of escape from the hordes of French schoolchildren who seem to take over the Buttermarket for much of the year.

By evening, however, the pub attracts a different kind of clientele, younger and often student, who hang out here to watch live sport, endure karaoke, sup lager and knock back garishly coloured shots. We were all young once.

THE THOMAS INGOLDSBY, BURGATE

Standing at the city wall end of historic Burgate, the Thomas Ingoldsby is an archetypal J. D. Wetherspoon pub, one of two in Canterbury. Burgate, or Burgate Street as it was originally known, was heavily bombed during the Second World War and as a result today's streetscape offers a mix of the very old and the post-war.

The Thomas Ingoldsby and the plaque dedicated to Richard Harris Barham.

Occupying a former furniture showroom, the Ingoldsby features a spacious L-shaped bar with a bright main area to the front and more secluded booths to the rear. Its central city location ensures a bustling mix of tourists, office workers, shoppers and locals, the latter sometimes animated and vocal.

Colourful Cleric

The pub is named after Richard Harris Barham, a colourful character who enjoyed considerable success in the mid-nineteenth century as a writer of both humorous novels and poems. Born at No. 61, Burgate in 1788, just yards from where today's pub stands, under the pen name from which the pub takes its moniker he penned the *Ingoldsby Legends*, a series of mock ballads in a medieval vein that were popular in their day and even more so after Barham's death in 1845. Originally appearing from 1837 as a regular feature in *Bentley's Miscellany* magazine, edited by a young Charles Dickens no less, the *Legends* met with considerable commercial success when later published in omnibus book form.

Born into a wealthy local family, Barham was only seven when his father died. His inheritance enabled him to enjoy a good education, attending St Paul's School in

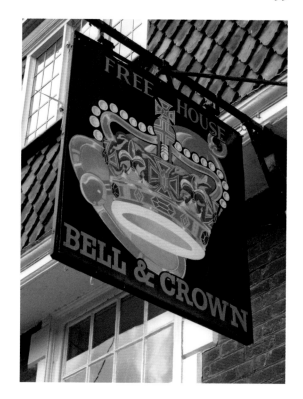

The Bell and Crown, Palace Street.
Pub sign and bar.

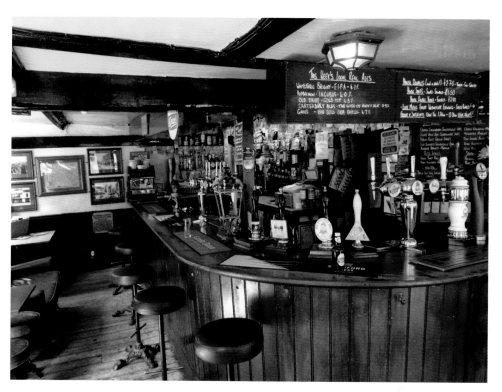

London and later Brasenose College, Oxford, where he secured a degree in law. During his time at Brasenose, however, he accrued gambling debts and returned to Canterbury to lick his wounds. Here he founded the Wig Club, a convivial society of friends who met at No. 61, Burgate and in the summer months held boisterous roustabouts in the walled garden facing Canterbury Lane.

Despite his degree in law, the death of his mother in 1813 affected him deeply and he instead became a clergyman, a career giving him the freedom to also pursue literary interests. He preferred to write at night and liked to sip gin as he did so.

In 1930 a rather grand plaque was unveiled at No. 61 Burgate to mark the place of Barham's birth. Alas this plaque went missing, presumed destroyed, when the house took a direct hit from a Luftwaffe bomb. It has since been rediscovered and can today be seen on the wall of the charity shop which now occupies the site.

THE BELL AND CROWN, PALACE STREET

There are many Canterbury pubs that can claim legitimate and strong connections to the Cathedral, but the Bell and Crown in Palace Street has perhaps more right than most.

Although there are records of a house here as early as the thirteenth century, the earliest notice of premises being licensed as a pub at No. 10 Palace Street date from 1862 and it is most likely that its name commemorates the marriage that year of Princess Alice, Queen Victoria's second-eldest daughter, to Prince Louis, the Grand Duke of Hesse. On such occasions bells would ring out across the land, hence the not uncommon pub name of the Bell and Crown.

The pub is now a freehouse but over the years has been under the auspices of various brewers. Worth looking out for are a lovely etched glass window of some antiquity marking a link to famous Canterbury brewers George Beer and Co, and two signs confirming the Bell and Crown as a onetime Kent outpost of the famous East London beermaker Truman's of Brick Lane.

A sign outside details each Archbishop of Canterbury from Charles Thomas Langley in 1862 through to Rowan Williams in 2003. Particular reference is made to Arthur Michael Ramsey, who held office from 1962 to 1974. Ramsey liked a good pint of bitter and this is where he often came to get it.

No Bursars

Close by is another list of names, this one dedicated to the pub's various landlords down the years. It concludes with the words: 'Arthur Michael Ramsey was a frequent visitor to the Bell and Crown but it's thought unlikely that the present Landlord will be the next Archbishop.'

The pub stands directly opposite the venerable and exclusive King's School, founded AD 597, which lays claim to being the oldest in the world. Yet another notice on the pub wall declares that, among a long list of supposed miscreants, 'vagabonds', 'horse thieves', 'rapscallions' and 'especially bursars will not be served on these premises'.

In the pursuit of balance I should declare here that this is one my favourite Canterbury pubs, refreshingly unpretentious with no airs or graces. Indeed its interior,

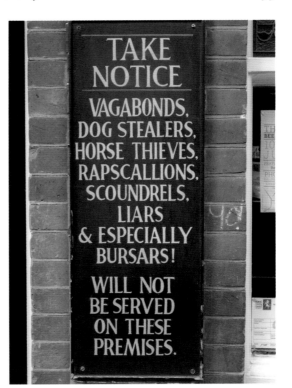

Right: Sign outside the Bell and Crown.

Below: Interior of the Bell and Crown.

while undeniably old, is rather sparse in a 1960s sort of way, although it has had a recent update. Despite which it doesn't take too great a feat of the imagination to picture, say, Caravan, stalwarts of the Canterbury music scene, holding a band meeting here over a few pints of Fremlins.

The pub, in addition to a splendid jukebox, also offers an excellent range of cask ales, notably from local microbreweries such as Hopdaemon of Newnham and Gadds' of Ramsgate.

Within the City Walls – South

BLACK GRIFFIN, No. 40 ST PETER'S STREET

The thing that I like about the Black Griffin is that is looks like a pub, and an old school pub at that. Even in 1999, when Oxfordshire brewery Wychwood acquired the place and changed its name to the Hobgoblin, it managed to stay looking like a pub, despite a garish new street sign that looked as if it had been lifted from a 1970s heavy metal album sleeve by Uriah Heep, possibly, or perhaps Budgie.

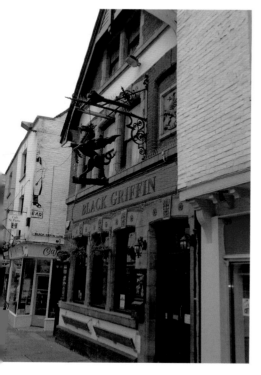

The Black Griffin, St Peter's Street, and its famous sign.

Hobgoblin is Wychwood's leading beer, a strong cask ale that packs quite a punch. I'm quite partial to a pint myself from time to time, but the quality of the aforesaid ale in no way justified changing a pub name that had been around for close on 400 years.

There has been an inn on this site in St Peter's Street since the very early seventeenth century, and very briefly it was called The Bull. But it has nearly always been the Black Griffin, with the current building dating from the late nineteenth century.

Return of Original Name

Indeed the Black Griffin was such a notable local landmark that a narrow thoroughfare that runs down one side of the pub is called Black Griffin Lane, which seems to make perfect sense. Hobgoblin Lane just wouldn't have worked.

So it was smiles all round when, in 2010, the pub once again became the Black Griffin. On reflection it is amazing that anyone has ever known it by any other name, for the sign of the Griffin remained hanging proudly inside and out despite the name change, not to mention two World Wars.

These days the Black Griffin is a popular haunt for students and has a suitably relaxed and bohemian air about it, even on Monday nights when live music is the major attraction.

Image of the Black Griffin inside the main bar.

CHERRY TREE, WHITE HORSE LANE

It is often said that Charles Dickens once stayed at the Cherry Tree, the strangely charming yet rough-and-ready old pub in White Horse Lane, just yards from the High Street. If there is any truth in this it is only a partial truth.

Dickens certainly visited Canterbury on several occasions and knew the city well. In Guildhall Street, on the side of what is now a Debenhams department store, is a plaque to mark the occasion in 1861 when he gave a reading from *David Copperfield* before a rapt audience at the old Theatre Royal, which stood here until its demolition in 1926.

There are also records that Dickens stayed at the old Fountain Hotel in St Margaret's Street, Canterbury's most famous inn until its destruction in 1942 by German bombs. It has also been claimed by some that the great writer spent time at the old Fleur de Lis Hotel, previously Fleur de Lis Inn, which stood on the corner of the High Street and White Horse Lane. If Dickens did indeed stay here, and it has never been convincingly proved that he did, he would surely have stayed in the hotel itself, not the tap? The tap, incidentally, is what later became today's Cherry Tree.

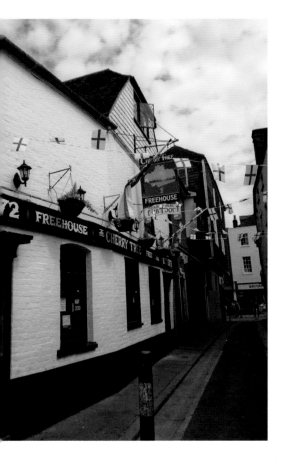

The Cherry Tree, White Horse Lane. Essential Canterbury.

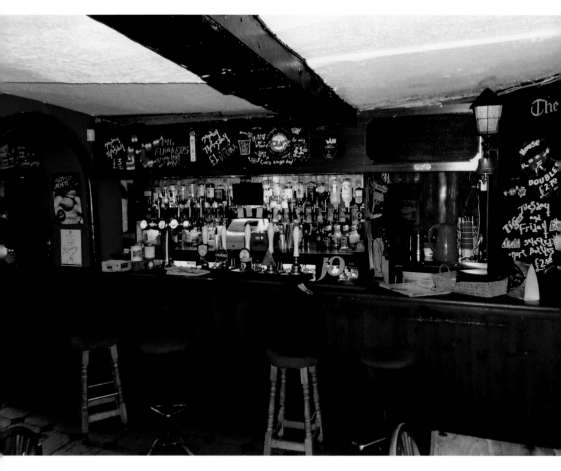

Interior of the Cherry Tree. Full of character and characters.

Fleur de Lis Tap and Stables

The Fleur de Lis Hotel is mentioned as early as 1376. It was certainly a building of some age and antiquity when it went the way of the wrecking ball and was shamefully demolished in 1958, a building that the Luftwaffe couldn't destroy wiped out post-war in the name of so-called progress.

To the rear of the Fleur de Lis, and harking back to its medieval origins, were stables and a tap where, in all probability, ale brewed on the premises was available to weary travellers. It is the Fleur de Lis tap, which can be dated to 1372, that we now know as the Cherry Tree, a name it adopted in 1949.

It once belonged to London brewer Charrington but has subsequently made a full recovery. It is now a freehouse carrying a decent range of ales and artisan ciders and has provided refuge for generations of tired and emotional students, who continue to make up a large proportion of its clientele. It is a pub assured of its own identity and with no airs or grace. It has lots of character, and plenty of characters. Long may it stay that way.

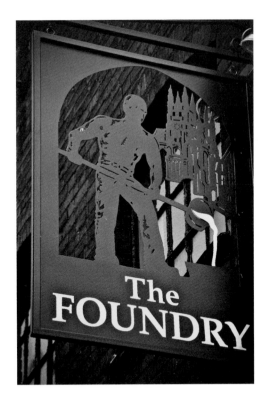

The Foundry, White Horse Lane, has revived brewing in Canterbury.

THE FOUNDRY, WHITE HORSE LANE

There has been talk in some quarters of a schism existing between the real ale and craft beer camps, but you'll find no such divide at The Foundry where quality cask ales are served alongside excellent craft offerings, most of it brewed in the pub itself.

Canterbury is still without a micropub – and East Kent was, after all, the birthplace of the micropub in the form of Martin Hillier's groundbreaking Butcher's Arms in the village of Herne – but this adventurous brewpub goes some way to making up for that.

The Foundry is housed over two floors in a former Victorian iron foundry. From here pieces of metalwork were once shipped all over the Empire while New York streetlamps and some early versions of the torpedo were also manufactured, the latter for the Royal Navy. The foundry was owned and run by an entrepreneur named William Henry Biggleston and he has been immortalised in malt and hops in the form of Biggleston's Birdman, a modest strength 'American' brown ale of some distinction.

Brewing Returns to Canterbury

Brewing equipment at The Foundry.

The Foundry is home to Canterbury Brewers, set up in 2011 by Jon Mills and Gary Sedgwick. From their modest microbrewery, which can be observed from the comfort of the airy ground floor bar, they produce an eclectic and sometimes mind boggling range of cask and craft beers that both tip their hat to the past while reflecting the latest beer trends.

So the hoppy Canterbury Pale Ale craft offering sits comfortably on the beer menu alongside Foundry Man's Gold, an easy drinking cask session ale and their best seller. Likewise the awesome Street Light Porter, which packs quite a punch, seems quite at home rubbing shoulders with the equally potent Foundry IPA, inspired by American craft brewing. For Halloween a few years back they produced a pumpkin beer.

The Campaign for Real Ale (CAMRA), formed in 1971 as a reaction to the spread of keg beer, hasn't quite worked out how to deal with the explosion in (mostly keg) craft beer. Despite which, if members of the organisation show their CAMRA card at the Foundry bar they'll get ten per cent off their pint.

You will also find Foundry beers at another Canterbury pub, namely the City Arms Inn in Butchery Lane.

Tom Sharkey (left) and Jon Mills brewed a pumpkin beer.

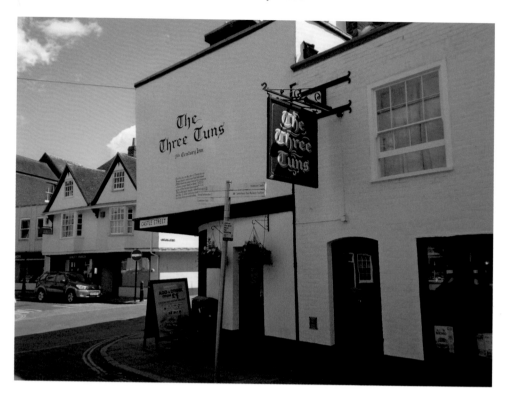

The Three Tuns in Watling Street

THREE TUNS, WATLING STREET

Canterbury took its fair share of punishment during the Luftwaffe bombing raids of the Second World War, not least during the infamous 'Baedeker Blitz' of 1 June 1942, in which high-profile places that featured prominently in the Baedeker series of guides were specifically targeted.

The area around Watling Street certainly suffered on that fateful day, and a stroll around the locality today reveals a not always smooth juxtaposition of the ancient and the post-war. Certainly The Three Tuns, an attractive old pub on the corner of Watling Street and Castle Street, is clearly a relic of a bygone age. And we should be grateful that is has survived at all, for it was badly damaged in 1942 and could so easily have been replaced post-war with a bland concrete box.

The pub, and indeed the bare bones of the current building, can be traced back to the sixteenth century and it is a listed structure boasting a number of original features, both inside and out.

Although it started life as The Three Tuns, at some point in the eighteenth century it changed its name to the Queen's Head and, as the Queen's Head Hotel, for many years offered accommodation. The queen in question, incidentally, was probably Queen Bertha of Kent, wife of King Ethelbert. A statue of Bertha stands proudly today, only a brisk walk away at Lady Wooton Green, not far from the ruins of St Augustine's Abbey.

Livery Companies

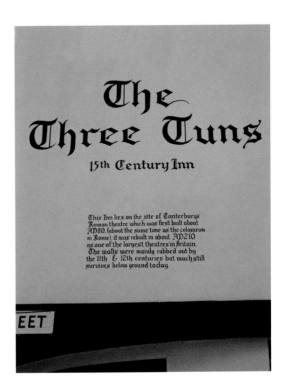

The Three Tuns is proud of its antiquity.

In 1988 the pub reverted to its original name, thought to have been inspired by the coat of arms of two City of London Livery Companies, the Worshipful Company of Vintners and the Worshipful Company of Brewers, both of which feature the three tuns. A tun is a large cask used to store beer or wine.

The pub stands on part of the site of a Roman amphitheatre dating from around AD 270. With a capacity of more than a thousand it was one of the biggest of its kind in the Empire outside Rome. However, when the Romans left Canterbury it fell into disrepair and was eventually pulled down, its valuable stone taken to be used elsewhere.

As the Queen's Head the pub is remembered fondly by some as a Whitbread house during the 1960s and 1970s. Today part of the John Barras chain of pubs.

LIMES, ROSEMARY LANE

A combination of Second World War bombs, so-called 'slum clearance' and property development has over the years rather robbed fragrantly named Rosemary Lane of much of its character. However, about midway along the Lane, opposite a council car park, you'll find Limes, Canterbury's sole gay bar and an establishment that certainly brings a bit of colour to an otherwise fairly dull thoroughfare.

It is housed in a lovely old building which claims a date of 1820, although there has been a hostelry here of one sort or another since at least the fifteenth century.

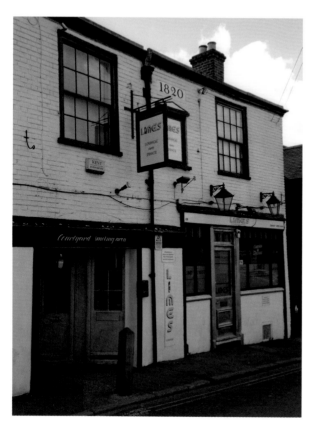

Limes in Rosemary Lane,
formerly the Cardinal's Cap.

For many years the pub was known as the Cardinal's Cap. It belonged to Maidstone brewer Fremlins for some time and offered accommodation as recently as the 1960s. It was a Courage pub for a while, during which time it boasted a sign depicting a cardinal, in the titular cap, grinning wildly, perhaps after a tincture or two too many. As the elements started to take their toll on said sign the cardinal looked more and more like a Francis Bacon portrait of Father Jack from cult TV sitcom *Father Ted*.

Blind Dog

The Cardinal's Cap was a live-music venue briefly in the late 1990s, but in 2001 it became the Blind Dog, which seems to have taken its inspiration from the Blind Dog at St Dunstans, a pub located in St Dunstan's Street that was itself named after a 1976 album by leading Canterbury music scene band Caravan. It was not their finest hour.

In 2013 the Blind Dog was acquired by Tony Butcher and he has transformed it into Limes. Now established as the city's only gay bar, it is fair to say that there have been a few teething problems along the way, not least complaints from some neighbours about excessive noise and a bizarre incident in March 2014 when a 'clergyman', not a cardinal one suspects, visited the pub and, according to one local newspaper report, 'offered to "cleanse" its customers and cure them of their homosexuality'.

THE WHITE HART, WORTHGATE PLACE

The White Hart, Worthgate Place.

There are several pubs in Canterbury that claim to be haunted, but the White Hart in Worthgate Place probably has better ghostly credentials than most. Much paranormal activity has been reported here over the years, which given the site that the pub occupies and the fact that what is now its cellar was formerly used as a mortuary is not surprising. Indeed the body chute can still be seen to this day, which does rather suggest a play on the phrase 'dead drunk'.

One preposterous story that occasionally does the rounds tells of a young man in the mortuary who, not quick enough on his feet, was buried beneath a fresh delivery of cadavers. The poor chap's cries apparently went unheard, and he was soon pushing up the daisies himself.

These days the cellar is more likely to be full of beer from Faversham's Shepherd Neame brewery, who have owned the pub for several years now and oversaw a major refurbishment programme back in 2011.

In a previous life it was a Whitbread house, as indeed many pubs were in this neck of the woods.

St Mary de Castro

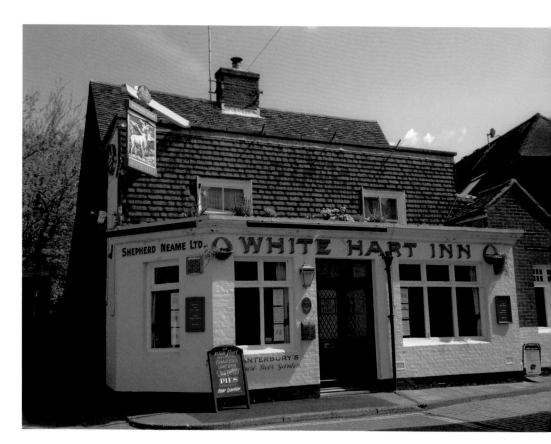

The White Hart was built on the site of a church.

More plausible on the ghost front are reports from staff over the years of strange noises, shifting shapes caught out of the corner of an eye and the occasional spectral sighting of people wearing 'Victorian style' clothing. You sups your pint and makes your own mind up, I suppose.

The pub itself dates from 1837 and is built on part of the site previously occupied by the church of St Mary de Castro, although records show the St Mary itself was demolished in 1486. The small piece of greenery to the left of the White Hart was formerly the church graveyard and ancient tombstones can still be seen lining the perimeter wall.

The pub today boasts of having 'Canterbury's largest beer garden', with part of the area given over to the historic pub game of bat and trap. The game is these days almost exclusively played in Kent, and in particular East Kent, and for many years the White Hart was a noted venue. So much so that in 1954 the BBC Radio Newsreel programme sent reporter Douglas Brown along to cover the Canterbury and District League clash between the White Hart and the B-team of the Dolphin at St Radigund's Street.

CARPENTER'S ARMS, BLACK GRIFFIN LANE

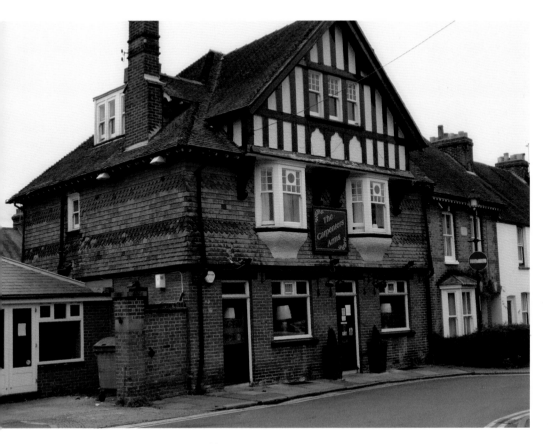

The Carpenter's Arms, Black Griffin Lane.

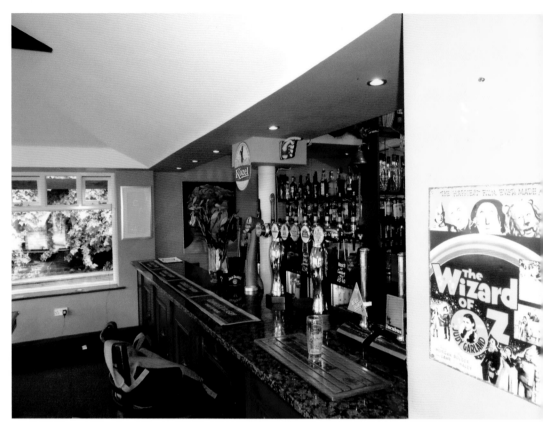

The Carpenter's Arms, Black Griffin Lane.

It can't be easy running a backstreet pub in this day and age, but The Carpenter's Arms seems to be doing just fine. Although it is barely a minute on foot from busy St Peter's Street, it is actually located in a quiet residential area and passing custom is probably at a premium.

But the pub clearly has its devoted regulars, and is also popular with students who are attracted by a range of keg beers, both mainstream and 'designer', at very reasonable prices. The pub also boasts two pool tables, live sport shown across several screens and the kind of wallpaper you sometimes come across in boutique hotels. Your typical hall of residence has never been noted for its fancy wallpaper.

The Carpenter's Arms has been a popular British pub name since the seventeenth century and historically Canterbury has not bucked the trend. What is now the Lady Luck in St Peter's Street, for instance, went by the name until the 1760s, when it became the Three Compasses. Another Carpenter's Arms existed in Northgate Street from the early nineteenth century but soon changed its name and is sadly no longer with us.

This surviving Carpenter's Arms started life in the 1830s and the current building dates from around the turn of the century, its size increased somewhat by a modern conservatory extension that leads to a small patio. The pub is run by the same people

behind the wonderful Crown and Bell in Palace Street, although is an altogether different kind of place.

OLD BREWERY TAVERN, STOUR STREET

An annexe of the Abode Hotel, which is situated in the High Street, The Old Brewery Tavern is located in Stour Street, and with its separate dining and bar areas is rather sedate and more than a little swish during the day. There's also a nice courtyard if you fancy going alfresco

At night, however, things start to change. The whole place gets much busier and, according to the Tavern's website, there is 'an unparalleled party atmosphere'. A real Jekyll and Hyde place it would appear.

The reason I include it here, however, is because of the range of beer available. Time was when all you could expect to get drinks-wise at a nightspot was a selection of spirits, a rather predictable list of cocktails and perhaps a mainstream, bog standard lager. How things have changed.

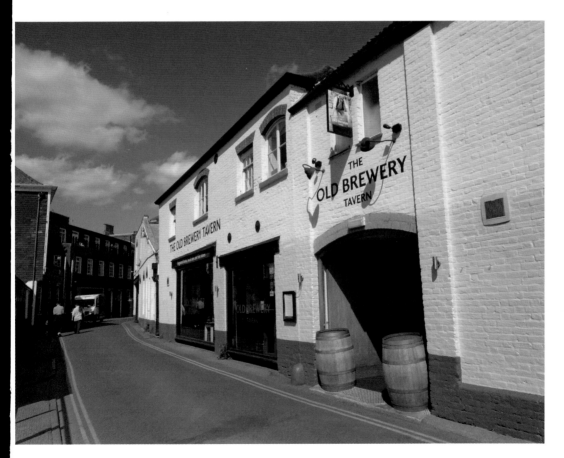

The Old Brewery Tavern, Stour Street.

Craft Beer and Real Ale

Drinking habits are changing in this country and more and more young people are moving away from mass produced lagers and instead turning to cask ales and, in particular, craft beer.

The craft beer movement started in America and has rapidly established itself in this country with many home grown producers now turning out their own often complex and sometimes dynamic keg beers. Early suspicions were that the whole craft beer thing was another fad, a case of emperor's new clothes for the tattooed urban hipster brigade. But it seems craft beer is here to stay, and they now represent one of the fastest growing sectors of the drinks market. Indeed craft beer now features as one of the basket of goods used to calculate inflation.

There is a good craft selection available at the Old Brewery Tavern, both on draught and in bottle, alongside an equally decent choice of cask ales, with Kent micros such Gadds', Hopdaemon and Wantsum well represented.

As for the Old Brewery Tavern name, the famous Stour Street Brewery once stood nearby. A stroll around the corner will bring you to Beer Cart Lane. Now, there's a name to conjure with.

Outside the City Walls

THE WEST GATE INN, NORTH LANE

If you had found yourself near North Lane back in 1850, and just happened to have a thirst about you, then you would have been spoilt for choice in your search for an obliging hostelry.

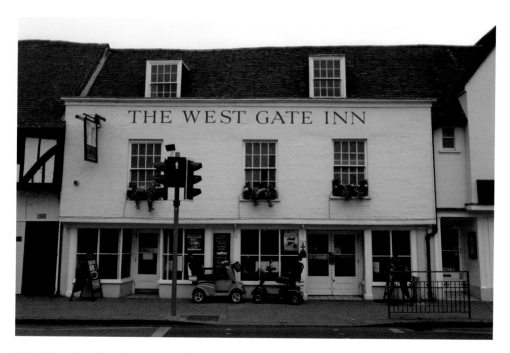

The West Gate Inn. Note mobility scooters parked outside.

At No. 5 you would have found the Falstaff Tap, in all probability with a strong connection to the Falstaff Hotel around the corner in St Dunstan's Street. At No. 20, meanwhile, was the William IV, while five houses along from there was the Blue Anchor, which closed as relatively recently as 1971. And that's before we come to mention the Steam Packet or the Woolpack. It's not even as if North Lane is a terribly long thoroughfare.

It is a sad sign of the times then, and proof that pub closures are not unique to our age, that these days your choice is limited to just one pub, the West Gate Inn at the Westgate Towers end of North Lane. This is Whetherspoon's second hostelry in Canterbury, alongside the Thomas Ingoldsby at Burgate, and is a pretty standard 'Spoons affair.

Falstaff Tap Swallowed Up

The West Gate Inn opened in 1999 and is named after the nearby Westgate Towers, an imposing medieval gateway that once marked the most prominent entrance into the walled city of Canterbury.

The pub is wider than it is deep and connects a number of once separate old buildings, some of them very old as the small example of surviving exterior timber framing confirms. The end result is sturdy and no doubt functional, if perhaps a little underwhelming.

The West Gate Inn was knocked through to swallow up the aforementioned Falstaff Tap, which had closed the year before, no doubt inheriting some of the old pub's customers along the way.

Like most Weatherspoons establishments the pub attracts a diverse and sometimes characterful clientele, and seems especially popular with the users of mobility scooters. The sight of several scooters parked outside the pub sparked one local newspaper to run a mildly amusing story back in 2014 about using these mobility aids after perhaps a pint or two too many. A police spokesman told the *Kentish Gazette*: 'A mobility scooter is a mechanically propelled vehicle and it is an offence to drive one under the influence.'

BISHOPS FINGER, ST DUNSTAN'S STREET

Considering how heavily Canterbury was bombed during the Second World War it is amazing how many buildings of genuine antiquity have survived in St Dunstan's Street, among them the Bishops Finger pub close to the Westgate Towers.

The building itself dates from 1692 and was formerly a set of cottages that were reconfigured into an inn, and a few years ago the exterior was given a bold but suitably traditional makeover by owners Shepherd Neame.

For many years the pub was known as the George and Dragon, but after a major renovation in 1969 reopened as the Bishops Finger. As such it is one of Canterbury's best known and photographed pubs.

This change of name was inspired by an award-winning strong Kentish ale, Bishops Fingers, brewed by Shepherd Neame. This magnificent chestnut-coloured bitter was first brewed by the Faversham brewer back in 1958, essentially to mark the country's emergence from post-war austerity and, perhaps more fittingly, the end of malt rationing for the brewing industry.

The Bishops Finger, St Dunstan's Street.

Thomas Becket

Almost sixty years later it remains one of Shepherd Neame's best-known ales and was the first UK beer to be awarded Protective Geographical Indication status by the European Union, alongside products such as champagne and Melton Mowbray pork pies. This means Bishops Finger can only be brewed with genuine Kentish hops and water from the brewery's artesian well.

The beer takes its name from the ancient fingerposts, or bishop's finger signs, that were once common in this part of Kent, particularly on the Pilgrim's Way where they would have been directing travellers to Canterbury and the shrine of Thomas Becket. Becket, incidentally, is also the patron saint of the Worshipful Company of Brewers, one of the City of London's oldest and most prestigious livery companies.

The Bishops Finger remains a busy and vibrant pub that manages to combine a contemporary feel with Kentish pub tradition, something reflected in a mixed clientele. A long beer garden to the rear is surprisingly secluded while the bow windows to the front afford a great chance to people watch.

A pub of the same name, also owned by Shepherd Neame, can be found near Smithfield meat market in central London.

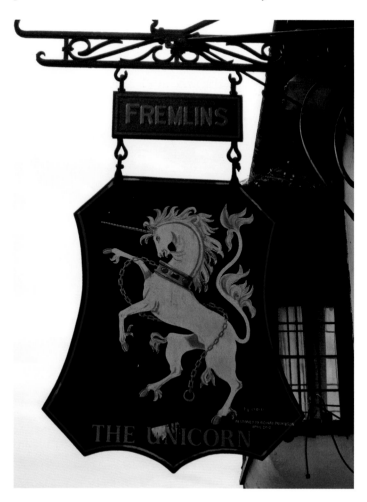

Fremlins once ruled
at The Unicorn, St
Dunstan's Street.

THE UNICORN, ST DUNSTANS ROAD

What's in a name? Well quite a lot sometimes, especially when it comes to pubs. Take the dear old Unicorn in St Dunstan's Street for instance, one of Canterbury's most venerable old hostelries.

Ale has been sold at The Unicorn since the 1660s and records show that in 1741 Susannah Sorrell sold the inn to one Stephen Stokes. Determined to put his own stamp on the place, Stokes promptly changed its name to the Star. This did not go down well with the locals and barely a year after Stokes, no doubt with one eye on the fall in his takings, changed it back to The Unicorn, and it has been The Unicorn ever since, surviving two World Wars and the arrival of the railway.

Local Brewery

What would become The Unicorn was originally built in 1593 as a house for Robert Budden, a prosperous woollen merchant. By 1664 it was selling ale and during the course of its long history it has changed hands on numerous occasions.

In 1815 it was bought by Flint and Kingsford, one of many brewers operating in Canterbury at the time. Certainly during this period in The Unicorn's history the beer didn't have far to travel. The Flint Brewery was actually located just yards away on the opposite side of St Dunstan's Street, behind the wonderful Roper Gate, which for many years was incorporated into the main brewery structure.

The brewery has long since gone, its famous chimney remembered only in photographs, but the Roper Gate survives, a fine example of Tudor brickwork. In time, as brewery consolidation saw several mergers and takeovers, The Unicorn became a Rigden's pub and then a Fremlin's pub. Indeed a rare hanging Fremlins sign can still be seen outside, although sadly the company long since stoped trading.

Not that there's any shortage of decent beer here. The Unicorn has long been renowned for both the variety and quality of its cask ale and the local branch of CAMRA voted it best local both in 2014 and 2015. Certainly if it's an authentic old school pub you are looking for then this fits the bill, dark and snug with exposed beams for good measure. They've even got a bar billiard table. Just put your money down and wait your turn.

This is also a pub that takes its quizzing seriously. In 2003 a team representing The Unicorn were the first ever to beat the Eggheads on the eponymous television programme of the same name. They collected £13,000 for their efforts. No doubt the drinks were on them that night.

THE BOTTLE SHOP, STATION ROAD WEST

I include the Bottle Shop in this book because, while strictly speaking it isn't a pub as such, the discerning drinker can still make a purchase and then sit here in gentle contemplation and sip that purchase. They even sell a limited range of beer on draught.

And what a choice there is! At any one time around 400 different bottles of beer are available here. Indeed founder Andrew Morgan and his team claim to carry a bigger variety than any other outlet in the south east, including London. This is a place that demands several return visits, all in the name of research naturally.

The Bottle Shop occupies a corner of the Goods Shed, an award-winning foodie emporium situated just yards from Canterbury West station and based in what was once, yes you guessed it, an old British Rail goods shed.

Opening for business in 2002 as one of the area's first farmer's markets, the idea behind the venture was – and remains – to promote and sell quality produce, the majority of it local and usually fresh from farm, field or sea. It can be a bit pricey, but if you care about the provenance of what you eat and drink then this is the place for you.

The Bottle Shop follows this ethos, and although it stocks beers from all four corners of the world is also particularly strong on its range of local produce. So, many of Kent's microbreweries are represented here, from the well-established Gadds' and Hopdaemon through to relative newcomers such as Mad Cat at Brogdale and the excellent Goody's of Herne. There is, quite literally, something for everybody.

The Bottle Shop (left) is located within The Goods Shed.

THE MONUMENT, ST DUNSTAN'S STREET

If you are entering Canterbury from the Whitstable Road then the first pub you will encounter is the Monument in St Dunstan's Street, on your left. The pub stands opposite the very old and very venerable St Dunstan's church.

There has been a hostelry at 37 St Dunstan's Road since at least the early eighteenth century and it takes its name from a stone monument that once stood opposite, midway between the pub and the church across the street.

However, as Paul Skelton points out on his excellent Dover Kent Archives website, more recent versions of the pub sign have for some reason featured an image of the First World War monument that stands in the Buttermarket, opposite the Christ Church gate entrance to the Canterbury Cathedral precincts.

Students and Pilgrims

The St Dunstan's suburb itself has a distinctly different feel about it than the rest of Canterbury, in part because of its location outside the old city walls and in part because of the number of historic buildings that have survived here. The Kent, North

East and East edition of *The Buildings of England* describes it as 'the handsomest and most consistent street in the city'.

A popular myth states that the head of Saint Thomas More, rescued from a pike on old London Bridge by his daughter Margaret Roper following his execution in 1532, rests in the Roper family vault at St Dunstan's. This has never been proved beyond doubt, despite which the church attracts pilgrims from all over the world who, after paying their respects to More, or at least to the spirit of More, would no doubt nip across the road for a restorative pint in the Monument.

Over recent years the Monument has built a reputation for itself as a lively place to watch big-screen sport, particularly football and rugby union, attracting in particular a large student clientele. The pub has hosted darts and bat and trap teams over the years, and also sponsored the University of Kent's rowers.

Some years ago it was a Fremlins house but has been under the ownership of Shepherd Neame for some time now. Alas, as I write these words, the pub is closed but scheduled to re-open following refurbishment.

THE EIGHT BELLS, LONDON ROAD

Eight is the usual number of bells in a church peal and so the Eight Bells is a common pub name throughout the British Isle. Canterbury once had two hostelries of that name but only one survives, at No. 34 London Road. But what a handsome old survivor it is, and a regular in CAMRA's *Good Beer Guide* to boot, featuring once again in the 2015 edition.

The Eight Bells, London Road (Paul Skelton).

The pub stands just yards from St Dunstan's church at the busy junction of St Dunstan's Street, London Road and Whitstable Road, which you'd think might explain its name. However, jolly old St Dunstan's only has six bells. This has prompted some to come up with another possible explanation for the pub's moniker, namely its close proximity to the medieval Westgate. When this was closed for the night, effectively securing the old city behind its walls and announcing the curfew, bells were sounded to warn those seeking to enter, and perhaps those seeking to get out. Could these be the bells that inspired the pub's name?

Either way, there has been a tavern here since 1708, when a substantial timber framed inn opened under the stewardship of one Nathaniel Laythem. Back then it offered accommodation to travellers and extensive stabling for their horses at the rear.

By the end of the nineteenth century, despite several patch-up jobs, the inn had fallen into a state of disrepair and was promptly pulled down. Work on its replacement started almost immediately in the spring of 1898 and local legend maintains that some of the timbers from the original building were incorporated.

The current pub opened for business in 1902 and is suitably Edwardian in standing. A distinctly old school boozer, regular quiz and karaoke nights remain popular.

THE FLYING HORSE, DOVER STREET

Standing resolutely on the corner of Dover Street and Upper Bridge Street, just beyond the city wall, is The Flying Horse, a proud and very old pub that perhaps looks a little out of place against a twenty-first-century backdrop of post-war architecture and the constant roar of passing traffic.

That it remains at all is remarkable, for it was bombed almost to the point of complete destruction during the Second World War and photographs taken the morning after the 1940 air raid show just a shell of a building. Demolition looked the most likely fate of the pub, but the then owners thought otherwise and it was reopened after lengthy rebuilding and renovation.

The pub also managed to escape the cross redevelopment of much of Canterbury during the 1960s, in particular the construction of the ring road and the building of Canterbury bus station in St George's Lane opposite. Some pubs of great antiquity were not so lucky, notably the Saracen's Head in Burgate which went the way of the wrecking ball in 1969, despite its fifteenth-century origins.

Coaching Inn

The Flying Horse dates from a little later, having been built in 1574. Today's surviving building clearly shows that there was once considerable stabling attached to the pub, and that's because it was one of the main coaching inns on the London to Dover run.

The coaching connection is probably also the reason for its name, and not an allusion to Pegasus, the winged horse of Greek mythology, as has been suggested. When the stage-coach boom happened in England these sleek and gleaming vehicles were regarded as the cutting edge technology of their day. They were sometimes referred to as 'flying machines', and the horses pulling them as 'flying horses'.

At previous times in its history it had been known as The Rose and, briefly, as the

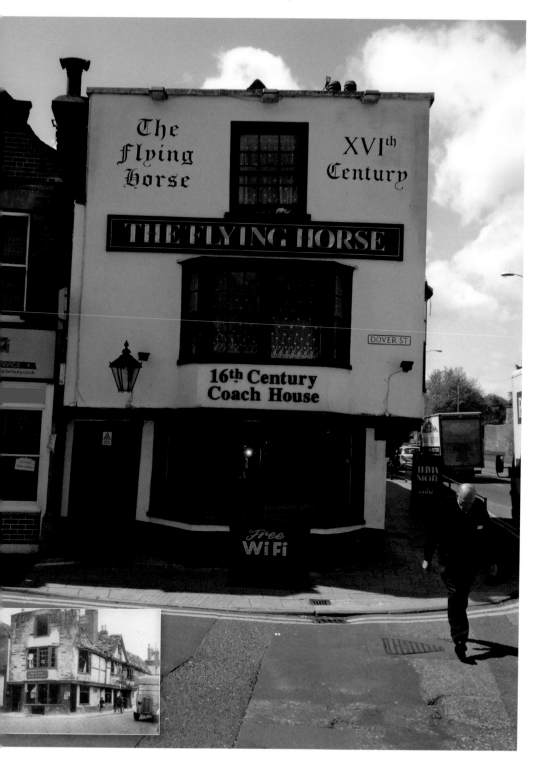

The Flying Horse after bomb damage (Paul Skelton) and today.

Three Musketeers. At one time or another it has been in the hands of a variety of breweries, including Rigdens, Fremlins, Courage and Whitbread.

Today it is a bright, spacious and upbeat modern pub inside what is in essence a sixteenth-century shell. It has long been a popular place to watch live sport.

TWO SAWYERS, IVY LANE

Given the amount of traffic that seems to be constantly roaring around the St George's roundabout, Ivy Lane really has no right to still be standing. Surely this pretty thoroughfare of mainly modest terrace houses should have been flattened back in the 1960s and replaced with a multi-story car park or a supermarket, of course, 'in the name of progress' naturally?

Fortunately Ivy Lane is very much still with us, a positive enclave of (relative) peace and quiet just yards from the ring road. And midway down, sandwiched between a hairdressing salon and a residential house, is the Two Sawyers, a delightful survivor from the days when small, backstreet boozers were still common.

Indeed, in addition to the Two Sawyers, Ivy Lane also once boasted the Fox and Hounds at No. 13, the Brewery Tap at No. 22 and the Navy Arms at No. 57. The Two Sawyers has been here since at least the 1780s and the current pub proudly displays a plaque reading 'circa 1796' outside today.

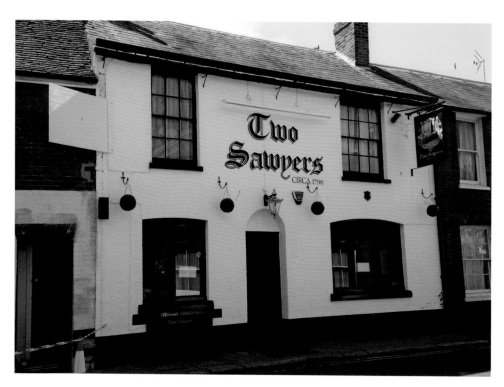

The Two Sawyers, Ivy Lane.

The bar of the Two Sawyers.

Unskilled but Thirsty

The sign of the Two Sawyers is not uncommon in this country and, as can be seen in Ivy Lane, usually depicts two men sawing. Carpentry and joinery were always regarded as skills, and as such had their own guilds and liveries. The mere sawing of wood, however, was deemed an almost menial and unskilled job.

But sawing is thirsty work, and even the snootiest carpenter would surely not begrudge their fellow workers in wood somewhere of their own to congregate and sup ale.

If a pub is going to cut the mustard in a tucked away location such as Ivy Lane it needs to really be at the top of its game. The Two Sawyers, a pretty pub both inside and out, seems to be doing OK. It manages to strike a nice balance between contemporary and traditional, which is no mean feat these days.

A plaque just yards from the pub marks the house where Mary Tourtel, creator of popular children's classic Rupert Bear, lived for a time. Whether she ever popped in for a pint of mild and a dose of inspiration we shall probably never know.

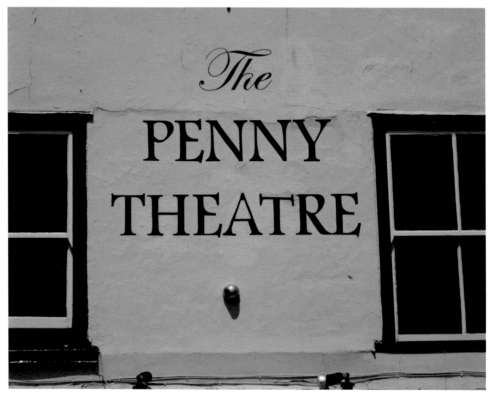

THE PENNY THEATRE, NORTHGATE

Entertainment of one form or another has taken place at Nos 30–31 Northgate since the mid-eighteenth century, and with its current programme of DJ sets and live music performances The Penny Theatre pub continues that tradition today.

The Alexandra Music Hall opened here in 1850 when a small auditorium was added to the rear of existing buildings that had probably hosted entertainment a hundred years previously. Despite the addition of a balcony in 1860 this remained a relatively small venue, covering barely 600 square feet in total.

During its long and varied life the venue had a number of different names, including the Princess Alexandra Theatre, Canterbury Music Hall and the Cannon. However it is The Penny Theatre that seems to have stuck. It closed as an entertainment venue around 1898 and in the years since has been used for a variety of things, including as storage space, a shop and, briefly, a theatre space once again. It is Grade II listed.

It was fleetingly an amusement arcade but since 1989 has housed The Penny Theatre pub, although for a brief period in 2008 it was converted into an outpost of the Scream chain of hostelries.

The Death of Judge Dread

Above: Judge Dread, remembered at the Penny Theatre.

Opposite: The Penny Theatre, Northgate.

The bar of The Penny Theatre.

The former music hall space, which boasts a capacity of around 300, was an influential live music venue throughout the 1990s, and among the bands that graced its stage before moving on to bigger, if not necessarily better, things are Radiohead, the Cranberries and Supergrass.

Perhaps the Penny Theatre's biggest claim to fame, or possibly infamy, occurred on the night of 13 March 1998 when controversial reggae singer Judge Dread played at the venue. Dread, real name Alexander Minto Hughes and the man behind a string of innuendo-laden hits such as 'Big Six' and 'Big Seven', had just completed a live show in front of a sold-out audience but, as he left the stage, suffered a fatal heart attack. A giant picture of the man himself graces the backdrop in the live music area.

A lengthy drinks menu detailing a variety of cocktails, 'shots', 'fishbowls' and 'popcorn pitchers' seems to confirm that today's Penny Theatre values its student customer base most highly and, all things considered, it is nice to see an entertainment legacy, of sorts, continue here.

NEW INN, HAVELOCK STREET

Running a successful pub isn't easy these days, and with more and more people choosing to do their drinking at home many are closing, as has been well documented of late in the media. Things are especially tough for the small, backstreet pubs that were once the norm rather than the exception, and without the passing footfall of larger high street hostelries they have to work twice as hard to get customers through the door.

So raise a glass and throw your hat in the air for The New Inn in Havelock Street, a quiet thoroughfare located off busy Broad Street. This small, narrow pub stands in the middle of a row of charming but unremarkable Victorian terrace houses, houses that would once have provided the majority of the pub's customers.

Given the economic lay of pub-land in 2015, Nhe New Inn has no right to still be trading. But here it stands, bustling with a mixed clientele of loyal local regulars and cosmopolitan students from the nearby Christ Church College. The two seem to get along just fine, coming together to quaff excellent cask ale and take part in the modern day communion of watching sport, mainly football, on the big screen. There is also a decent jukebox.

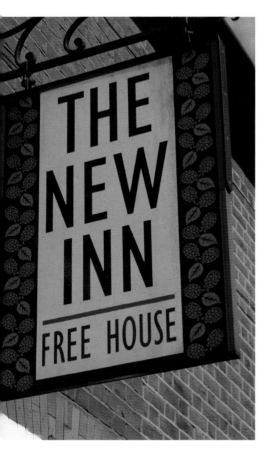
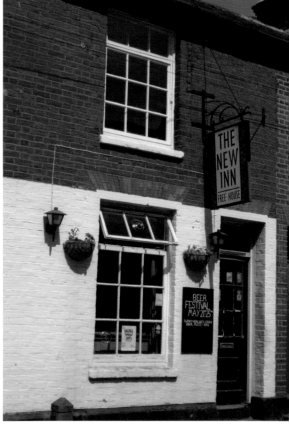

The New Inn, Havelock Street. A thriving backstreet pub.

Beer Festivals

The pub opened as the Vines in the mid-nineteenth century, at the same time as Havelock Street was developed.

The street is named in honour of Major General Henry Havelock, who forged his military reputation serving in India. It was at the tail end of the Siege of Lucknow in 1857 that Havelock met his end when dysentery did for him. A decent pint of IPA might have made all the difference.

Vines became the New Inn around 1865 and is essentially a terrace house with a pub in it. Although it appears small from the front it is surprisingly spacious, if narrow, within. A modern rear conservatory helps ease the crush, and a well-kept beer garden is popular when the elements allow. Many original Victorian features have been retained and there is a nice balance of the traditional and the contemporary.

A regular in CAMRA's *Good Beer Guide*, the pub is a freehouse and holds regular beer festivals typically featuring more than twenty cask ales and artisan ciders, the majority of them from microbreweries. I'll drink to that.

Further Afield

YE OLDE BEVERLIE, ST STEPHEN'S GREEN

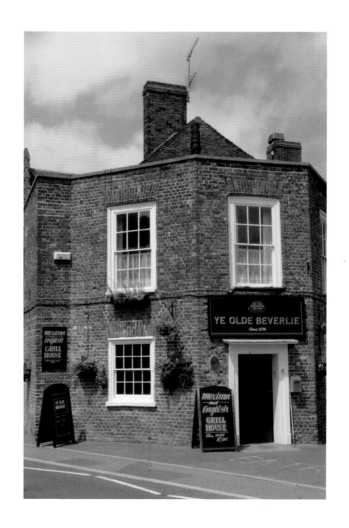

Ye Olde Beverlie, St Stephen's Green (Shepherd Neame).

Ye Olde Beverlie, St Stephen's Green (Shepherd Neame).

Although Ye Olde Beverlie is a brisk two-mile yomp as the crow flies from Kent CCC's St Lawrence Ground, this ancient pub on pretty St Stephen's Green can claim a unique place in both the evolution of cricket as a sport and the eventual formation of the county club.

In 1835, wealthy brothers John and William Baker formed the Beverley Cricket Club, one of several playing in Kent at the time. They played on Beverley Meadow, St Stephen's, on part of the family estate, and Ye Olde Beverlie was the club's *de facto* clubhouse. In 1839 a cricket week was staged here, drawing more than 4,000 spectators, and laying the foundations for the annual celebration of the sport that still takes place today under the Kent Cricket Week banner.

Beverley Cricket Club later became East Kent Cricket Club, attracting some of the best players in England, and many of the earliest first class matches played in the county were staged at St Stephen's. Hanging proudly inside today's pub is a poster from 1842 advertising a 'Grand cricket match' between sides representing 'Kent' and 'England'.

The many disparate sides playing in the county eventually came together under one

A reminder of the pub's rich cricketing history (Shepherd Neame).

collective umbrella in 1870 with Canterbury emerging as their headquarters.

Almshouses

Ye Olde Beverlie, also known over the years as the Old Beverlie Arms and the Beverlie Arms, is a Grade II-listed building of some distinction, dating from around 1570, although relatively little of the original building has survived. It was originally intended as living quarters for the warden of six adjoining red-brick almshouses, built by barrister, politician and philanthropist Sir Roger Manwood.

Because of this association, for many years the pub only had a six-day licence, remaining closed on Sundays. This changed in 1954 when it was taken over by Ramsgate brewer Tomson and Wotton. Ye Olde Beverlie is now part of Shepherd Neame's extensive pub estate and today food plays a big part in the pub's appeal.

Claims have been made over the years that the pub played an instrumental role in the invention of bat and trap, a sport almost exclusively played in Kent. It was certainly one of the six founding teams of the Canterbury and District Bat and Trap

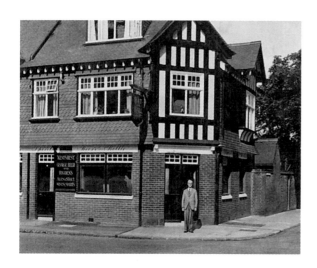

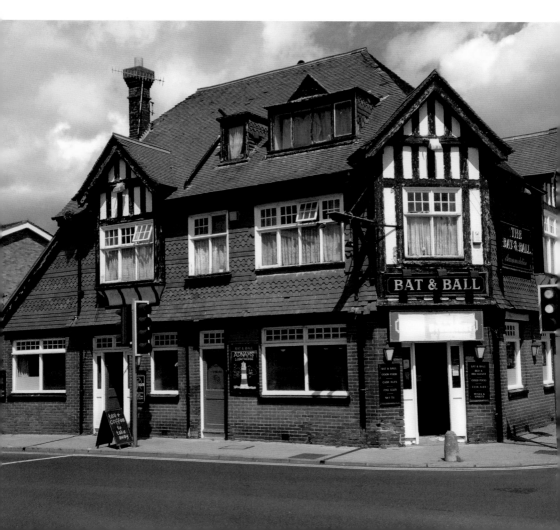

League in 1921 and this most intriguing of pubs games is still played here over the summer months.

BAT & BALL, OLD DOVER ROAD

Pubs located close to sports grounds always have a unique feel to them, and the Bat and Ball is no exception. Located opposite the main gates to Kent County Cricket's Club's famous St Lawrence Ground, or Spitfire Ground as it is also commonly known these days, this venerable old boozer has been quenching the thirst of both cricket fans and cricketers for at least a hundred years, most probably even longer.

The pub was originally known as the First and Last but changed its name once the popularity of cricket became apparent. Kent CCC first started playing at the St Lawrence Ground in 1847, and although they still play elsewhere in the county – at Beckenham and Tunbridge Wells for instance – the Old Dover Road venue is the club's headquarters.

In 1858, to reflect this and attract cricket fans, the First and Last became the Bat & Ball.

Fuller Pilch

Well into the 1990s the pub's sign depicted legendary Kent batsman Fuller Pilch. Although in a lengthy career Pilch played for several other counties, most notably Hampshire, Surrey and Sussex, it is with Kent that he is most famously associated and he played for them, off and on, between 1836 and 1854.

In cricket history he is regarded as a pioneering batsman, rated by some as the best England produced until the arrival at the wicket of W. G. Grace in the 1860s. However, records show Pilch's first class average to be a fairly modest 18.61.

The pub sign over the years usually showed Pilch resplendent in top hat and scarf, but minus gloves and pads. Cricketers were clearly made of stronger stuff back then.

In 1840, incidentally, Pilch became a publican himself and for many years combined his cricket career with the role of landlord at Canterbury's Saracen's Head, located on the corner of Burgate and Lower Bridge Street. Despite being one of the city's famous old inns, the Saracen's Head was demolished in 1969 as part of the construction of the city's ring road. At the time it was one of many pubs in Canterbury belonging to Fremlins.

Today the Bat & Ball, if perhaps a little rough around the edges, remains a vibrant and lively pub that buzzes with cricket talk and sometimes colourful banter. As such it remains part of the match day ritual for many who visit the Spitfire Ground.

THE PHOENIX, OLD DOVER ROAD

The Bridge House Tavern stood resolutely on the corner of Old Dover Road and Cossington Road for almost 100 years, dating from 1874. But in 1963 fire swept through the building and it was pretty much destroyed in the conflagration.

Even back in the mid-1960s a cold wind was blowing for Canterbury pubs, the

Opposite: The Bat & Ball *c.* 1940 (Paul Skelton) and today.

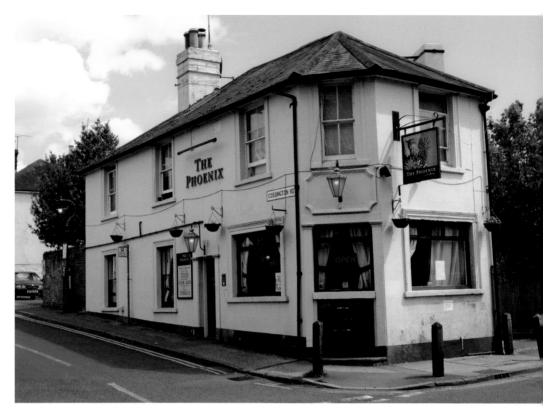

The Phoenix, Old Dover Road.

number of which was already in decline. And it could quite possibly have been a case of curtains for the poor old Bridge House, knocked down perhaps or converted into a residential property.

But, I am glad to write, after some painstaking renovation the pub finally re-opened not too long afterwards. Not to put too fine a point on it, it had risen from the flames. Rather aptly, it was renamed The Phoenix.

Pub Sign Mystery

Some sources suggest that a tavern operated on this site from the mid-nineteenth century when a number of houses were converted into alehouses, but it only became known as the Bridge House in the 1860s under the close watch of one Thomas Young.

For many years the pub was owned by the small Kent brewer Gardner's, who were based in Ash. They were eventually consumed by Whitbread Fremlins, who made a habit of that kind of thing at the time (Fremlins of Maidstone had itself been taken over by Whitbread).

When The Phoenix opened for business in 1968 it probably did so as a Whitbread pub, although today it is proud of its freehouse status. There is a possibility that at one time the old Bridge House was a Fremlins pub in its own right. That is if a number of

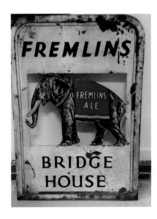

Today's Phoenix sign. But did Fremlins ever own the Bridge Tavern?

photographs sent to Paul Skelton's excellent Dover Kent Archives website are anything to go by. They show a battered old pub sign, complete with the brewery's famous and majestic elephant logo, bearing the name Bridge House.

These days the pub is run by husband-and-wife team Bob and Nilla Griffiths, who had previously been at the old Rose and Crown in St Dunstan's. They are both passionate about real ale and in addition to an ever-changing range of cask beer, with several usually available at any one time, hold regular beer festivals.

The pub is only a short walk from Kent CCC's Spitfire Ground and is popular with spectators after and sometimes before matches, hopefully only rarely during.

THE OLD CITY BAR, OATEN HILL PLACE

Oaten Hill, as the name rather bucolically suggests, was once the location of Canterbury's cereal market. However, it also boasts a rather darker history, for it was here that a place of execution, later the city gallows, were sited and many an unfortunate was hanged, most famously the Oaten Hill Martyrs, four Catholics who met a dreadful end here in 1588. In 1929 they were beatified by the Vatican.

Going by the name of the Old City Bar since the late 1980s, there's been a pub at Oaten Hill Place since the eighteenth century when it was known as the City of

The sign of the Old City Bar, Oaten Place.

Canterbury. Its location directly opposite the gallows must certainly have been good for business as the grisly spectacle of watching a man – or woman – hang attracted huge and, no doubt, thirsty crowds.

The landlord of the City of Canterbury was known to offer the unfortunate felon breakfast prior to execution. It is not recorded whether the condemned man did indeed eat a hearty breakfast or not. Perhaps he opted for muesli and a cup of decaf instead?

Change of Name

The last hanging at Oaten Hill took place in 1799 and in the 1860s the pub became the Old City of Canterbury. This was most probably to avoid confusion with the City of Canterbury pub at St Thomas Hill on the road to Whitstable, even though the two hostelries were some two-and-a-half miles apart as the crow flies.

Today Oaten Hill, and Oaten Hill Place where the elegant and rather handsome Old City Bar stands, is a well-heeled Canterbury environ just a short walk from the city walls. The pub, recently renovated and refurbished, is smart and upmarket, combining the Georgian basics of the building with a distinctly contemporary feel. It majors on food and good ale.

Opposite stands a surviving oast house, once used to dry locally grown hops. It is today owned by Canterbury Christ Church University.

Live sport is also a big draw and, not surprisingly given the close proximity of Kent CCC's Spitfire Ground, fans of the summer sport congregate here before and after games to discuss googlies and leg breaks and Joe Denly's batting average.

The pub has had a variety of owners over the years, including Fremlins and

Whitbread, but is now part of the Shepherd Neame stable under the guidance of Chris Smythe, who oversees a number of other pubs in Canterbury. Things seem to be going swimmingly.

THE CROSS KEYS, OATEN HILL

As a fully paid-up atheist I am probably not best placed to give an opinion on whether frequenting public houses and drinking alcohol will bring you closer to your god. But what is beyond any doubt is that in this country the link between the church and the tavern has always been a strong one.

Take the Cross Keys on the corner of Oaten Hill and Old Dover Road for instance. The Cross Keys is a fairly common pub name across the British Isles and is probably a reference to St Peter, who was entrusted with the keys to heaven by Jesus Christ.

And although this particular pub is located a mile or so from Canterbury Cathedral, much of the land outside the city walls was once given over to religious organisations and the Benedictine Priory of St Sepulchre stood where today's pub is sited.

Former Bakery

There has been a pub located here since the late seventeenth century. It was originally named the Trumpet and became the Cross Keys sometime in the mid-eighteenth

The Cross Keys, Oaten Hill.

The Cross Keys, Oaten Hill.

century.

For many years part of the pub premises was given over to the old Kingsfield Bakery. When that left in the late 1950s an electrical wholesaler took space, although in the passing of time they too departed. It was for a while a rare Canterbury outpost for Ramsgate brewer Tomson and Wotton and in the 1970s transferred from Whitbread Fremlins to Charrington.

It looks like the kind of grand-old pub, Georgian in scale and style, that one would expect to see dominating the main square of a country market town. These days, however, rather than farmers discussing pig swill and the cost of grain, you are more likely to encounter football fans discussing the offside rule.

The Cross Keys, you see, is a big sports pub and makes a claim to be 'Canterbury's premier sports bar'. It should be noted, however, that it is not the only pub in Canterbury to make such a claim, although being so close to Kent CCC's Spitfire Ground probably helps, in the summer months at least.

When Martin Luther wasn't busy nailing 'statements of belief' on church doors, he was coming up with succinct statements such as: 'Whoever drinks beer, he is quick to sleep; whoever sleeps long, does not sin; whoever does not sin, enters Heaven! Thus, let us drink beer!' He would have been right at home at the Cross keys.

TWO DOVES, NUNNERY FIELDS

Where there is beer there is quite often bread, for the two have been intrinsically linked throughout the history of mankind. The Germans, who know a thing or two about both, refer to beer as 'liquid bread'.

The Two Doves, Nunnery Fields.

So there is a nice historical symmetry in the fact that the charming Two Doves pub in Nunnery Fields started life in the 1880s as a bakery, run by an enterprising local called Edwin Coppen. Back then Nunnery Fields was an almost totally self-sufficient suburb of Canterbury with its own butcher, abattoir, post office and baker.

A public house, the Nunnery Tavern, was a prominent feature of the newly-built Lansdown Road from the 1870s, located just off Nunnery Fields, but it was clear that one hostelry was not enough for this fast developing neighbourhood and so in time Coppen's bakehouse also became an alehouse. The Nunnery Tavern, incidentally, closed for business in 1968 and is now a private house.

Nunnery Fields takes its name from the fact that this land originally belonged to the old Benedictine Priory of St Sepulchre, and it was rural and largely agricultural until the 1860s when the arrival of the railway started to change the area.

Rural Survivor

Nunnery Fields today couldn't be less bucolic and is a busy road along which traffic seems to speed at most hours of the day. But the Two Doves stands resolute in the face of this onslaught, a proud survivor of a long gone age.

To perhaps get some idea of what the area was once like, and indeed what drinking in the Two Doves must once have been like, it is worth investigating the pub's rear bar. The Two Doves stretches someway back down leafy Caledon Terrace, a small turning which is positively sleepy compared to Nunnery Fields just yards away, and the contrast between the two is remarkable.

Over the years the pub has been part of the Fremlins estate and from the early 1970s

The sign of the Two Doves.

was owned by Shepherd Neame. These days it is a freehouse. It is perhaps an indication that a large proportion of the pub's custom comes from local residents that during the week it doesn't open for business until the afternoon.

MAIDEN'S HEAD, WINCHEAP

It is perhaps hard to comprehend today, as inevitably heavy traffic crawls in both directions along Wincheap, that this area was once a leafy suburb of Canterbury. Back then, as one of the most important routes into the city, it boasted several substantial inns, many of them offering accommodation and stabling.

Of the two pubs that have survived the Maiden's Head is probably the oldest. Just. The timber-framed building itself is believed to date from the mid-fifteenth century and there are records that it was first given a licence to sell ale around 1570.

A malt house was mentioned as one of the pubs features when it was sold in 1742, suggesting that at the time the Maiden's Head both brewed and sold ale. This was confirmed in 1984 when the pub was renovated and Kent Archaeological Society took the opportunity to investigate. They found evidence that a brew house did indeed once stand to the rear.

The Maiden's Head was acquired by Faversham brewer Rigdens in 1754 and they owned it for many years. A surviving etched window to the front of the pub, possibly

Above left: The Maiden's Head, Wincheap.

Above right: The Maiden's Head is one of Canterbury's oldest pubs.

late nineteenth century and a thing of great beauty to behold, proclaims: Rigden's Fine Ales.

The pub was later owned by Fremlins and, as recently as the 1990s, by Whitbread. One particularly dark chapter in the pub's history came in 2013 when then landlord Ralph Latchana was sentenced to fifteen years in prison for stabbing Alexander Maclay, his wife's lover.

The Maiden's Head also made local newspaper headlines in 2012 following complaints of excessive noise. Since 2014 the pub, now a freehouse, has been under new ownership.

KING'S HEAD, WINCHEAP

Further along Wincheap, heading out of Canterbury, you'll find the King's Head. This is the thoroughfare's other surviving pub and it will take five minutes on foot to reach from the Maiden's Head.

En route you'll pass what was once the White Horse at No. 75, now a private

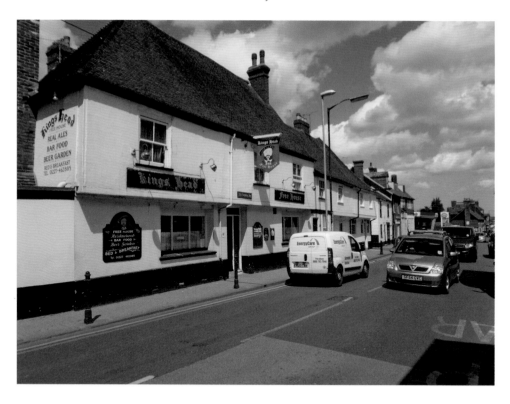

The King's Head, Wincheap.

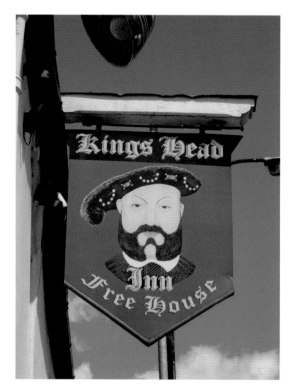

residence but a Whitbread pub until 1969, and at No. 89, on the opposite side, the Sportsman, a pub until the end of the 1960s but now a superior greasy spoon which has retained the old pub's name. This gives some indication of just how many pubs once operated in this area.

But sometimes it is quality that matters and not quantity, and the King's Head is one of the best old-school pubs in Canterbury; a distinctly down-to-earth place where you'll find suitably down to earth customers, good beer and satisfying pub grub.

The King's Head dates from the fifteenth century and enjoys Grade II listing. It would once have offered accommodation and stabling facilities for travellers who chose to stay outside the city walls, or arrived to find the city gates closed for the night. The pub still boasts 'three cosy well equipped en suite letting rooms' and I'm sure if you looked hard enough you'd find somewhere to tie up your horse.

Bat and Trap Venue

Over the years the pub has been under the control of several local brewers, including Flint and Co. of Canterbury, Rigdens, Fremlins and Whitbread. These days it is a freehouse and regularly features in CAMRA's *Good Beer Guide* for its range of cask ales, many of them from Kent microbreweries.

The pub boasts a dart board, once the norm but now sadly the exception, and also a bar billiard table. During the summer months bat and trap is played in the rear garden.

The exact evolution of this ancient Kent pub sport has been lost in the mists of time but it is believed to have originated in this part of East Kent, possibly at Ye Olde Beverlie in St Stephen's. When the Canterbury Bat and Trap League started in 1921 it featured six founding teams, although only two of them – the Golden Lion and the Two Brothers – still compete. However, as both pubs closed long ago they now play their 'home' games at the King's Head.

RUN OF THE MILL, STURRY ROAD

It is common for British public houses to take their name from major historical events and Wellington's famous victory at Waterloo has inspired more than most. It certainly explains why, sometime shortly after 1815, the Ordnance Arms at No. 47 Sturry Road changed its name to the Waterloo Tavern. It is now called the Run of The Mill.

Canterbury has always had a strong military connection and from the early nineteenth century thousands of troops were stationed here in a series of purpose-built barracks, most of them outside the city walls and heading towards the ancient suburb of Sturry.

The Waterloo Tavern, originally the Ordnance Arms when it first opened around 1812, was such a pub, and it is highly likely that some of the troops stationed in Canterbury would have fought under Wellington against the French. So the change of name was certainly apt, and made great business sense too.

Barrack Closures and Name Change

But times change and the number of troops stationed in and around Canterbury had been in decline for many years, which might go some way to explaining why, in 2007,

the Waterloo Tavern became Saxby's, perhaps to reflect the pub's changing clientele.

It wasn't Saxby's for long, however, and around 2010 changed to the Run of The Mill, one assumes as a reference to the local Barton Mill, an imposing and historic complex that once stood nearby and was demolished in 2006. In the years following its demolition investigation by archaeologists uncovered traces of Neolothic and Roman occupation.

In March 2013 it was announced by the Ministry of Defence that Howe Barracks in Littlebourne Road would close and two months later the Argyll and Sutherland Highlanders embarked on an emotional final parade through the streets of Canterbury. Although there remains a Territorial Army base in Sturry Road, not far from the Run of The Mill, that last parade effectively marked the end of a meaningful military presence in Canterbury, and the disappearance of at ease squaddies 'on the town' has certainly given the city centre pub experience a different feel.

Howe Barracks is likely to be redeveloped as housing, changing once again the demographic of this part of Canterbury. What this will mean long term for the city's remaining pubs remains to be seen but one hopes 'suburban' hostelries such as the Run of The Mill will continue to serve the thirsty citizens of CT1.

FORDWICH ARMS, KING STREET, FORDWICH

The Fordwich Arms, Fordwich.

Although Fordwich is around three miles from Canterbury as the crow flies, this tiny town retains a strong connection to the cathedral city. And despite Fordwich's size – it has a population of less than 400 and is reckoned to be the smallest town in the country – it boasts two excellent pubs, of which the Fordwich Arms is one.

Located next to the River Stour, and standing directly opposite the charming and compact sixteenth-century Fordwich town hall, the Fordwich Arms is an attractive red-brick building dating from the mid-1930s but, from the outside at least, looking much older. Inside some wonderful 1930s period fittings survive, and very nice they are too.

However there has been an inn on this site since the fifteenth century, although the town of Fordwich itself is much older and reckoned to have sprung from a Roman settlement. A catastrophic fire destroyed the previous tavern in the early 1930s.

Perhaps Fordwich's strongest link to its much bigger neighbour is that for many years the town was the port of Canterbury, and indeed remains a Cinque Port of Sandwich. Back then the Stour was a much wider river and an important transport highway providing a link between Canterbury and the Continent. The majority of the Caen stone from Normandy, for instance, used to build Canterbury Cathedral was

The sign of the Fordwich Arms.

unloaded in Fordwich. It sounds like thirsty work, unloading Caen stone, and might explain why such a small town found itself with two sizeable pubs.

Keys to an Ancient Church

The Fordwich Arms can boast one of Kent's most picturesque pub gardens, and to sit here on a summer evening accompanied by birdsong and a pint of good beer is one of life's small treats. The garden looks out upon the Stour, much narrower these days and used only by the occasional pleasure craft.

Towering over the garden is the magnificent broach spire of the church of St Mary the Virgin, which stands a minute or so stroll from the pub. Norman in origin, and Grade I listed, the church is now redundant and overseen by the Churches Conservation Trust.

The church interior is wonderfully atmospheric and is sometimes used to stage art exhibitions and small, intimate live music events. There are some fourteenth-century stained-glass windows too. If the church is locked up just pop into the Fordwich Arms and ask to borrow the key.

THE GEORGE & DRAGON, KING STREET, FORDWICH

One of the masterpieces of British cinema, and a much neglected masterpiece at that, is Michael Powell and Emeric Pressburger's magical and mystical *A Canterbury Tale*.

The film was shot at a variety of locations in East Kent over the summer of 1943, including Fordwich. There are also some remarkable scenes of a badly bombed Canterbury, which give a good idea of just how badly the city centre suffered during the infamous Baedeker raids the spring before.

The George & Dragon is the first of Fordwich's two pubs that you encounter upon entering the town from Sturry, and there has been an inn on this site for around 500 years.

The Hand of Glory

A Canterbury Tale is loosely Chaucerian in theme, telling the story of three very different characters, two men and a young woman, who are thrown together in wartime Kent. All three of them have lost their way in life and all three are engaged on personal pilgrimages of their own.

Director Michael Powell had grown up in this part of Kent and his love for the place and the people shines through. It is a lovely and deeply human film.

Many scenes take place in a fictional pub, the Hand of Glory, and these scenes were mostly shot in the George and Dragon. The pub also provided accommodation for several members of the cast and production unit and it remains a place of pilgrimage for fans of the film.

The George and Dragon is also said to be haunted by a ghost known as the lady with the green hat, and over the years members of staff have spoken of a disconnected telephone that still rings from time to time.

In 2005 paranormal investigators spent time here and a lengthy report resulted from their investigation claiming that spirits 'roam quite freely' and that there were also signs of 'poltergeist activity.' It concluded: 'Table tilting and glass movement were

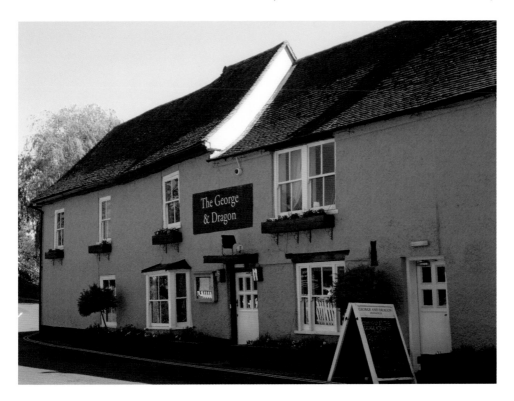

The George & Dragon, Fordwich.

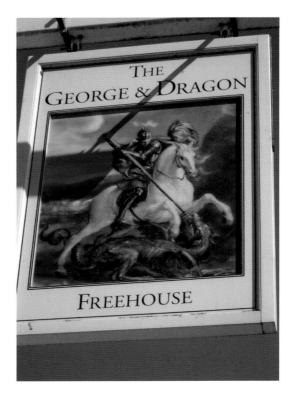

good.'

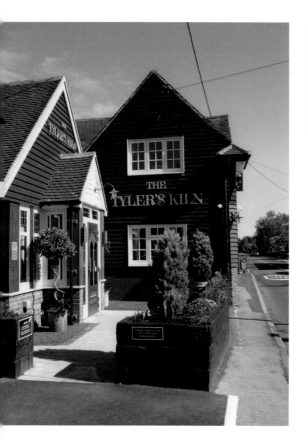 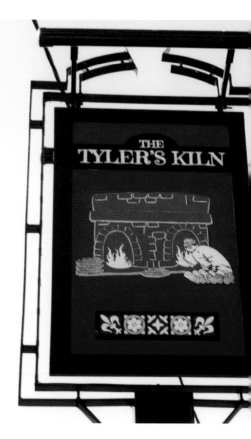

The Tyler's Kiln, Tyler Hill.

Many years ago the pub was owned by Canterbury brewers Flint and Sons and later spent some time as an outpost of the Beefeater Steak House chain. Today it is owned by the independent Home Counties Pub company.

TYLER'S KILN, HACKINGTON ROAD

Tyler Hill is a small village just outside of Canterbury that takes its name from the fact that during the medieval period it was the centre of pottery and tile making in Kent. Several hundred years later, pieces of pottery and ceramic dating from the middle ages are still occasionally found by ramblers.

Set in the heart of the ancient Blean wood, Tyler Hill today boasts a population around the 500 mark and is famed for its Bonfire night celebrations, widely regarded as the most spectacular in the county and regularly attracting 5,000 strong crowds.

If it's liquid refreshment they are after then The Tyler's Kiln is the nearest hostelry, although they might all struggle to get in at once.

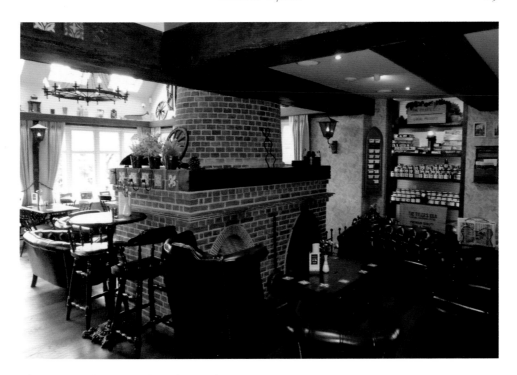

The recreated kiln at The Tyler's Kiln.

The interior of The Tyler's Kiln. Arts and Craft influenced.

Ivy House

Originally known as the Ivy House, the pub reopened early in 2015 as the Tyler's Kiln following an investment of more than £1 million. When the Ivy House closed a few years back plans were afoot to convert the building into student accommodation. The University of Kent, after all, is just a brisk walk away on the way into Canterbury.

But locals Allister Collins and Ben Fitter had other ideas, and after an extensive refurbishment and renovation it opened its doors for business as a modern-day village pub, combining elements of the traditional with the contemporary and managing to appear ever so slightly upmarket. Which isn't to say that you can't sit by the open fire on a solemn winter afternoon with a newspaper and pint, because you can.

The pub has been finished to an incredibly high standard, and the interior is dominated by a recreation of a tyler's kiln. It is lit during the winter months and looks quite spectacular. As one of the few amenities in the village, the pub also stocks a small range of basic goods such as bread, milk and sugar. Marmite too, I am glad to report. This is an excellent example of a village pub that has adapted to the twenty-first century, where others might well have closed down.

ROYAL OAK, BLEAN COMMON

As with buying a house, location can be a vital aspect when it comes to running a successful pub, as Tim Gibson, onetime landlord of the Royal Oak discovered back in 2009. Despite being on a busy road, it seemed that little of the traffic almost constantly flowing by outside between Canterbury and Whitstable was bothering to stop at this attractive old country pub, which dates from the 1880s.

Gibson, who admitted that he had just two regulars, resorted to desperate measures and erected a sign outside his pub reading 'customers wanted', or words to that effect. It might not have attracted many new drinkers at first, but it did catch the eye of the local *Canterbury Adscene* newspaper. Their story was promptly picked up by regional television, and when they filmed a news item that the pub barmaid Rachael Hardingham featured prominently.

What followed was an increase in the number of customers for the Royal Oak, a mini-media storm and offers of modelling work for Hardingham, a resident of nearby Herne Bay who told the *Adscene* that outside of work she enjoyed tinkering with vintage cars and hairdressing. 'I like anything that is hands on,' she said.

News of the World

Among the job offers that came Hardingham's way was one from *The Sun* newspaper to appear in their regular page-three feature, and another to 'star' in a reality television programme. 'If the pub does go to the wall I'm going to be her agent,' Gibson told the *Adscene*. 'It's gone global – I even did a seven-minute slot on Radio Alberta in Canada. People have been coming in from miles away. On Tuesday, which is normally dead, we were outrageously busy – the place was packed.'

It is not on record what happened to Hardingham and her modelling career, but she seems to have enjoyed her fifteen minutes of fame. As for the doughty old Royal Oak, the pub is very much still with us, although now under different ownership.

THE OLD COACH & HORSES, CHURCH HILL, HARBLEDOWN

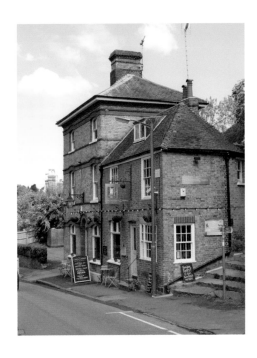

The Old Coach & Horses, Harbledown.

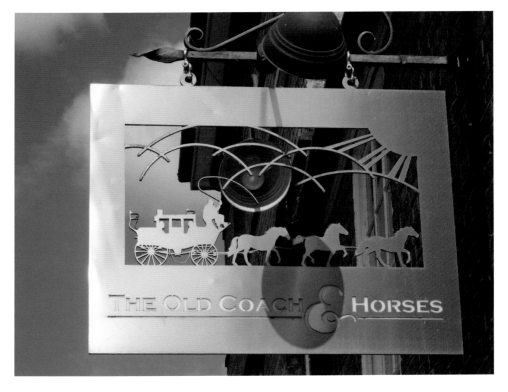

The traffic along Rheims Way can seem unrelenting and unforgiving at times, but if you take the first turning on the left after progressing onto the A2050 bypass you will find yourself climbing Summer Hill and in the charming and historic settlement of Harbledown.

Suddenly all is quiet and you are in another world almost, one that is so quintessentially an English country village that you half expect to see Miss Marple cycle past on her way to buy some rich tea biscuits. In reality, however, you are little more than a mile west of Canterbury's city walls. This change of environment can come as a bit of a shock to the system, so if you know what's good for you you'll nip into the elegant Old Coach and Horses for a restorative drink.

As the name suggests, this was once a coaching inn and a stop off point on the busy and important London to Canterbury route. The pub dates from the 1760s and it was many years after that the adjective 'old' was tagged on to the name.

First View of Cathedral

There is no doubting the village of Harbledown's antiquity. This was where London pilgrims on their way to Becket's shrine in Canterbury would have caught their first sight of the city and the Cathedral. It must have been a remarkable feeling to finally glimpse your intended destination after several gruelling days of travel. There is a strong likelihood that many of these pilgrims would have rested here, possibly overnight, before completing their journey.

Running a village pub these days can be a challenging business and the Old Coach and Horses appears to have risen to that challenge. Behind its solid and stolid exterior is an interior with a distinctly contemporary feel about it.

Unless you live in Harbledown this is very much a destination venue, but the pub enjoys a good reputation for the quality of its 'modern British' cuisine and people do travel here to eat. On some websites the Old Coach and Horses has been called a 'gastropub'. There are worse things to be called.

GENTIL KNYGHT, KNIGHT AVENUE

When the London Road Estate was developed just south of the village of Harbledown in the early 1950s it was decided to name the newly laid out streets after Chaucerian characters. So we got, and indeed still have, Wife of Bath Hill and Priest Avenue. There is even a Merchants Way and a Franklyn Road.

So it must have made absolute sense when building a spankingly modern new pub for the estate to follow suit and so, in July 1958, the Gentil Knyght first opened for business in Knight Avenue. It has been serving the local community ever since, although its immediate future is far from crystal clear.

Beer at Pre-war Prices

At the pub's grand opening former MP John Baker White did the honours, pulling a ceremonial pint. Beer for that opening evening was sold at pre-war prices and a pint would have cost you just 10*d* in old money. I think it's a fair assumption that some singing around the piano was also in order on that first night.

The London Road estate doesn't perhaps get the best press in Canterbury, but despite its problems a strong sense of community remains and over the years the pub has more than played its part in this, although a drugs raid by police back in January 2014 was perhaps not great for its reputation.

For many years the pub has been one of East Kent's leading bat and trap venues, often chosen to stage cup final tournaments by the Canterbury and District League. Formerly a Whitbread pub, it is now overseen by Shepherd Neame.

YE OLDE YEW TREE INN, WESTBERE

Westbere is a small and picturesque village around four miles from Canterbury, and it claims to have the oldest pub in Kentin in Ye Olde Yew Tree Inn, which given the antiquity of some taverns in Canterbury itself is some claim.

The building was certainly built sometime in the fourteenth century, with the current pub website stating 1348. There is, however, some debate as to whether it has housed a pub for the whole of its undoubtedly long history. Either way it can claim a colourful and eventful history, not to mention a couple of ghosts.

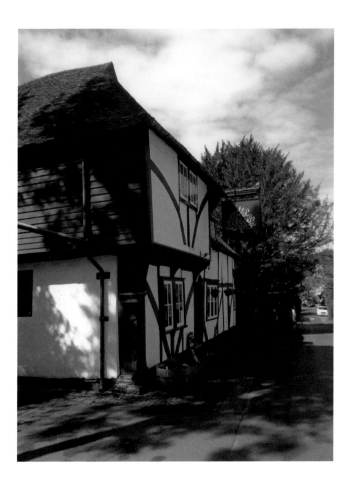

Ye Olde Yew Tree, Westbere.

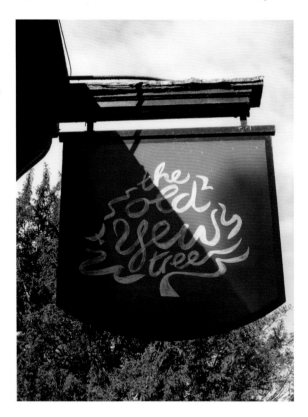

The sign of Kent's oldest pub?

Dick Turpin

Among the many who have stayed here over the years are Queen Anne and the Archbishop of Canterbury, although probably not at the same time and very definitely not in the same room.

A more colourful figure connected with the pub is Dick Turpin, if legend is to be believed the most dashing of all dashing highwaymen. When Turpin wasn't being dashing, or holding up coaches or stealing horses, he liked nothing more than to hang out in pubs like Ye Olde Yew Tree, quaffing ale and ogling wenches. It was at this old Westbere pub that Turpin once took refuge while on the run. Turpin, it seems, spent quite a bit of his time on the run.

The pub was also used as a makeshift hospital during the English Civil War, and a number of wounded soldiers were cared for here.

Today there is an altogether calmer air about the place. It is certainly one of the prettiest pubs you are likely to encounter, and its setting besides Westbere Lake is stunning, although in the summer months you will struggle to make out the water for the trees. The pub's interior is also a joy to behold, boasting original oak beams and a remarkable inglenook fireplace.

The pub caters to village locals and also customers who travel from further afield. Ye Olde Yew Tree has a good reputation for its food. I wonder whether old Dick had the Sunday roast or the bangers and mash?

Acknowledgements

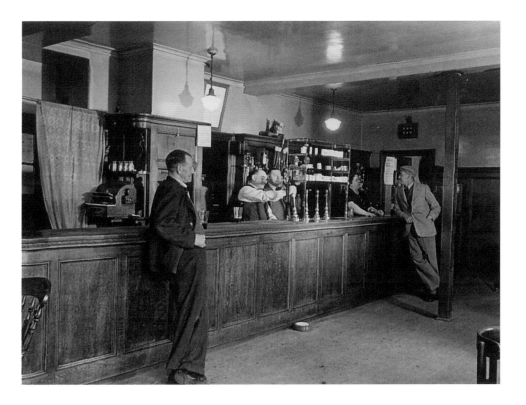

There are quite a few people without whom this book would have been much harder to write and put together. I would like thank John Humphries and his team at Shepherd Neame for answering my numerous enquiries and also for allowing me to use some of their photographs; also to all my friends at the Shepherd Neame Visitor Centre for their encouragement and enthusiasm. I would also like to say a big thank you to Jon Mills and Tom Sharkey of Canterbury Brewers, based at the wonderful Foundry Brewpub. They have, rather symbolically, revived the industry of brewing inside Canterbury's

city walls after an absence of many years. I particularly enjoyed my fascinating chat with Tom. I would also like to especially mention Paul Skelton, the man behind the wonderful Dover Kent Archives website (www.dover-kent.com). This has proved an invaluable source of information, and I am also grateful to Paul for allowing me to use several images from the website. Much of the research for this book was undertaken in public libraries in Canterbury, Faversham, Swalecliffe and Whitstable. Long may these vital public resources be with us. Use them or lose them. Lastly I would also like to give a big pat on the back to every landlady and landlord across the British Isles, and of course the staff who work for them. Running a public house is a challenging affair these days, but they continue to be a much loved British institution that often serve as a focal point for their local community. We would be a poorer nation without them.